WOMEN
OF TAROT

An Illustrated History
of Divinators, Card Readers,
and Mystics

CAT WILLETT

RUNNING PRESS
PHILADELPHIA

Running Press
Hachette Book Group
1290 Avenue of the Americas, New York, NY 10104
www.runningpress.com
@Running_Press

First Edition: June 2024

Published by Running Press, an imprint of Hachette Book Group, Inc.
The Running Press name and logo are trademarks of Hachette Book Group, Inc.

The Hachette Speakers Bureau provides a wide range of authors for speaking events.
To find out more, go to www.hachettespeakersbureau.com or email HachetteSpeakers@hbgusa.com.

Running Press books may be purchased in bulk for business, educational, or promotional use. For more information, please contact your local bookseller or the Hachette Book Group Special Markets Department at Special.Markets@hbgusa.com.

The publisher is not responsible for websites (or their content) that are not owned by the publisher.

Print book cover and interior design by Amanda Richmond.

Library of Congress Cataloging-in-Publication Data
Names: Willett, Cat, author, illustrator.
Title: Women of tarot : an illustrated history of divinators, card readers, and mystics / Cat Willett.
Description: First edition. | Philadelphia : Running Press, [2024] | Includes bibliographical references and index.
Identifiers: LCCN 2023038837 (print) | LCCN 2023038838 (ebook) |
ISBN 9780762482870 (hardcover) | ISBN 9780762482887 (ebook)
Subjects: LCSH: Tarot. | Women mystics—Biography. | Women occultists—Biography.
Classification: LCC BF1879.T2 W44 2024 (print) | LCC BF1879.T2 (ebook) | DDC 133.3/2424—dc23/eng/20231120
LC record available at https://lccn.loc.gov/2023038837
LC ebook record available at https://lccn.loc.gov/2023038838

ISBNs: 978-0-7624-8287-0 (hardcover), 978-0-7624-8288-7 (ebook)

Printed in China

APS

10 9 8 7 6 5 4 3 2 1

For Tycho, my moon.

CONTENTS

The History of Tarot

HISTORICAL TIMELINE

Mamluk cards are used in the Middle East

1250s–1500s

Cards make their way from Italy to France via Jacopo Marcello, captain of a Venetian fleet

1440

Artist Bonifacio Bembo, a Renaissance painter, creates the Visconti-Sforza deck

1450

Artist Nicola di Maestro Antonio d'Ancona creates the Sola Busca deck in Venice

1491

Card games morph into poetry games for the wealthy

1500

Antoine Court de Gébelin hypothesizes that tarot cards stem from ancient Egypt

1700s

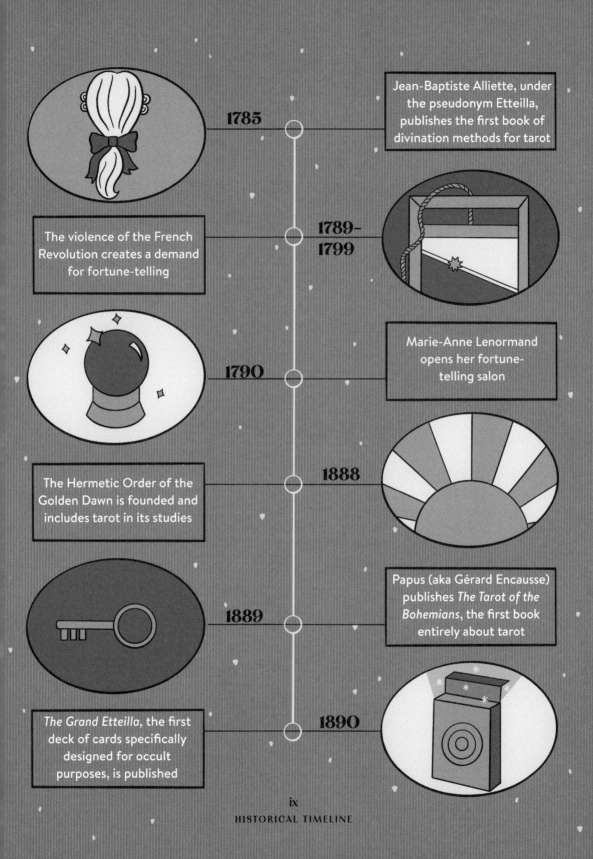

1785

Jean-Baptiste Alliette, under the pseudonym Etteilla, publishes the first book of divination methods for tarot

The violence of the French Revolution creates a demand for fortune-telling

1789–1799

1790

Marie-Anne Lenormand opens her fortune-telling salon

The Hermetic Order of the Golden Dawn is founded and includes tarot in its studies

1888

1889

Papus (aka Gérard Encausse) publishes *The Tarot of the Bohemians*, the first book entirely about tarot

The Grand Etteilla, the first deck of cards specifically designed for occult purposes, is published

1890

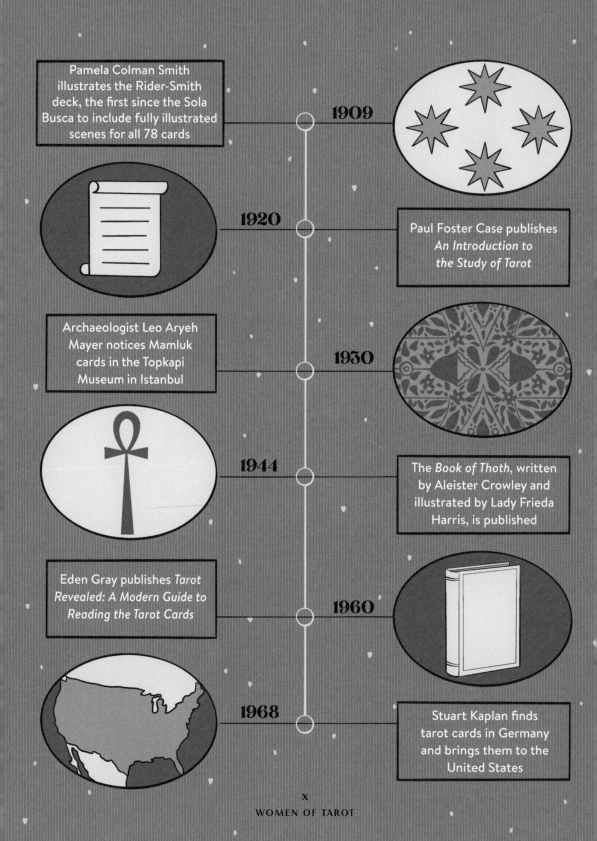

Pamela Colman Smith illustrates the Rider-Smith deck, the first since the Sola Busca to include fully illustrated scenes for all 78 cards

1909

1920

Paul Foster Case publishes *An Introduction to the Study of Tarot*

Archaeologist Leo Aryeh Mayer notices Mamluk cards in the Topkapi Museum in Istanbul

1930

1944

The *Book of Thoth*, written by Aleister Crowley and illustrated by Lady Frieda Harris, is published

Eden Gray publishes *Tarot Revealed: A Modern Guide to Reading the Tarot Cards*

1960

1968

Stuart Kaplan finds tarot cards in Germany and brings them to the United States

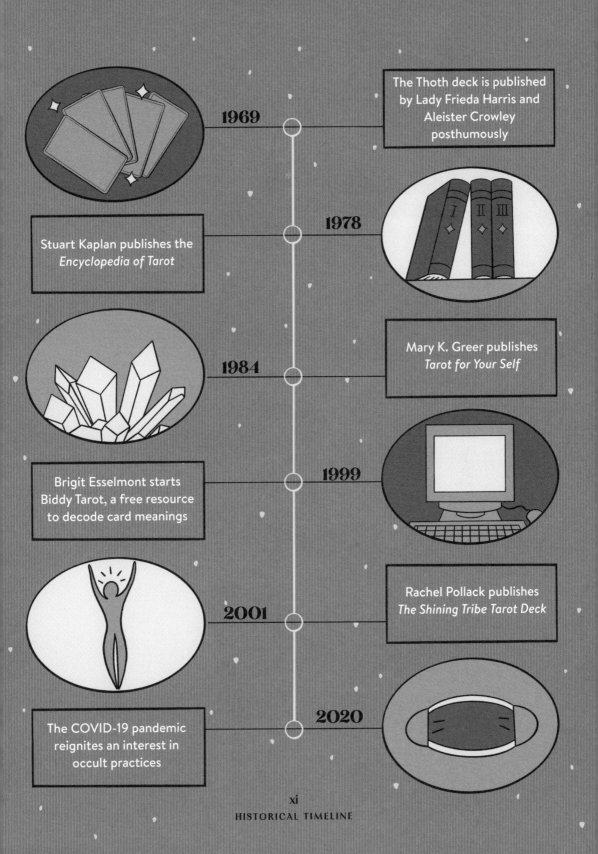

1969 — The Thoth deck is published by Lady Frieda Harris and Aleister Crowley posthumously

Stuart Kaplan publishes the *Encyclopedia of Tarot* — 1978

1984 — Mary K. Greer publishes *Tarot for Your Self*

Brigit Esselmont starts Biddy Tarot, a free resource to decode card meanings — 1999

2001 — Rachel Pollack publishes *The Shining Tribe Tarot Deck*

The COVID-19 pandemic reignites an interest in occult practices — 2020

AUTHOR'S NOTE

Although I have endeavored to include only factual information in this book, I want to note that the beauty of mystical history lies in its mystery. To ensure that the biographies have been told with as much accuracy as possible, I have drawn from a variety of sources to craft these stories. However, many dates and details remain unknown. I have tried to note in the text, whenever possible, when information is unclear.

INTRODUCTION

This book has been a labor of love and exploration—one that grew out of another project that has meant so much to me for many years. Through my work on *The Queen of Wands*, in which I highlighted the life and work of Pamela Colman Smith, I discovered many fascinating stories about women in the world of tarot, mysticism, and fortune-telling that span global history. What began as an exclusive card game reserved for the male elite has since grown into a tool of empowerment for people of all genders and walks of life. This profound evolution in the history of the cards and their use can be traced back to four key women and their efforts to make the realm of tarot more accessible to all. Moreover, these women have built off of each other's work, with their lives, philosophies, practices, and art often overlapping. My motivation behind telling their stories comes from my passion for surfacing historical women who accomplished incredible things but have not yet been celebrated. In addition to readers, tarot artists, and card experts, you will also discover other types of magical women in these pages. Mystics, fortune tellers, priestesses—women who lived outside of the spiritual conventions of their time and contributed to the overall world of mysticism. I hope that the following history of tarot, told through the lens of the women who've made it what it is today, honors their collective belief that there is more to life than what meets the eye and that magic is real.

The History of Tarot

The history of tarot is vast and complex. It spans different continents, centuries, and cultures, creating a rich tapestry of meaning that predates its present place in society. From party entertainment to fortune-telling, tarot card decks have taken on a multitude of roles throughout the ages as their use developed into the practice we recognize today. One thing has remained constant, though—women have been catalysts for tarot's evolution, transforming it over and over again to suit their needs and ultimately bringing it into our hands.

The tarot cards that we now buy online, in bookstores, or at flea markets are decks consisting of seventy-eight illustrated cards that are used to provide answers to important questions, gain insight into one's life, or evoke cosmic guidance. A tarot reader, whether professional or casual, will act as a liaison between the cards and the recipient of their guidance, expanding on their meaning for the subject of the reading, also called the querent. However, one can also practice tarot in solitude, conducting a private reading for oneself. Tarot is not connected to any specific spiritual practice and often appeals to those who don't subscribe to an organized religion. A reading can be a wonderful way to organize one's thoughts, set goals, or tap into one's intuition—and it requires only a deck of cards and a quiet space.

Historically, the invention of tarot is often tied to fifteenth-century Italy. While that time and place did play an important role in tarot's development, the cards actually evolved from a significantly earlier practice from a very different part of the world: Islamic Mamluk playing cards from the Middle Ages. Named for the Mamluk Sultanate of Egypt, which was the dynasty that ruled Egypt and Syria from 1250 to 1517, Mamluk cards were elaborately hand-painted works of art belonging only to members of the most elite class. When the Israeli scholar and archaeologist Leo Aryeh Mayer noticed Mamluk cards in the Top-

kapi Museum in Istanbul in the 1930s, he was able to date the deck and prove that they were in fact the basis for the Italian cards that would be developed later. While these cards did not include images of people, the Mamluk deck contains both suit and court cards and is a beautiful example of the artistic influence Islam had on the Western world. There are also signs that the Mamluk cards themselves evolved from even earlier versions of playing cards found in ancient China.

Over time, Mamluk cards were traded and brought to Western Europe, where they evolved into a new pastime for the upper classes and royalty. It was in the 1440s that Jacopo Marcello, a Venetian officer, sent a deck of cards from Milan to Duchess Isabella of Lorraine in France. This stunning gilded deck, along

with Marcello's letter to the duchess, was the earliest written reference to tarot, sparking an interest in decorated cards in the West that would last for centuries to come. While Marcello's missive named the cards as tarot, it's important to remember that, unlike the practice we know today, these medieval Italian gaming cards, known as *tarocchi,* were not considered to hold divine or fortune-telling properties. Instead, they were used only as multiplayer entertainment in the form of a game similar to what we might recognize today as bridge. The *tarocchi* included trump cards, or suits, but did not contain numbers.

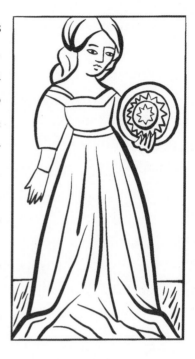

Around the year 1450, historians believe that the artist Bonifacio Bembo, a Renaissance painter, created the Visconti-Sforza deck for a noble family of the same name. This is one of the only complete Italian decks to have survived from this time period, and it gives us insight into what luxury fifteenth-century decks looked like—hand-painted, skillful, treasured, and slightly bigger than modern tarot cards. The cards also incorporated Christian symbology and figures, such as the pope.

In 1491, another trained Renaissance artist named Nicola di Maestro Antonio d'Ancona is believed to have created the Sola Busca deck in Venice. This was a turning point for the evolution of card games because, unlike the decks that came before it, the Sola Busca included the trumps from *tarocchi* as well as number (pip) cards, leading to a deck of seventy-eight cards that is the closest relative of the Rider-Waite-Smith deck—the most popular deck used today. Unlike the deck's earlier Islamic ancestors, the Sola Busca included full illustrations for each pip card, making it the first of its kind. D'Ancona engraved metal plates for each card so that they could be reproduced as hand-painted multiples. Although these repro-ductions were still only accessible to aristocrats at the time, they eventually made their way into private collections and museums, giving historians a more complete look at this deck than of many of its predecessors.

While the Sola Busca was the basis for the decks we use today, it would be diffi-cult for us to find our way with it, as the scenes are shrouded in symbolism many of us are no longer familiar with and require decoding. Though there's still much to be learned about the meaning behind the cards in the Sola Busca deck, current evidence does not suggest it was used in divination or fortune-telling.

In the hands of traders and mer-chants, tarot cards made their way from Renaissance Italy throughout Europe,

specifically to France, Switzerland, and Germany, where they experienced yet more reinterpretations. In Marseille, decks began to become standardized, in marked contrast to the previous decks displaying symbols related to specific noble families. The French word for *tarocchi* was *tarot*, and the result of the homogenization developed by French card makers was the Tarot de Marseille, a block-printed deck that became popular for gaming in the seventeenth and eighteenth centuries. This version of the deck included trumps and pips, but reverted

to the pre–Sola Busca decks in certain ways, with pips represented only with symbols rather than fully illustrated scenes. Much of the symbology in the scenes of earlier decks was also misinterpreted, leading to new iterations with relevance in their adopted cultures—as is often the case when art is transferred from society to society over time.

In some circles during the 1500s, these cards morphed into literary games in which wealthy French family members and friends would draw from the deck and write poems based on the cards. This approach was less about winning by trumping your fellow players and more about serendipity and chance, as players looked within themselves to craft a response to the symbology of the card pulled.

We see quite an impactful moment for the evolution of tarot in the late 1700s, brought about by a French scholar named Antoine

Court de Gébelin. When Court de Gébelin witnessed a group of people playing a card game in Paris, he hypothesized that the cards stemmed from the *Book of Thoth*, a secret ancient Egyptian text based on the teachings of Thoth, the deity of wisdom, writing, and, most importantly, sorcery. Court de Gébelin then published an essay making that claim and further stating that Egyptian priests had secretly passed this sacred text on to the popes of Rome, who later brought it to France. With this piece of writing, tarot became connected to a new world of esoteric and mystical practices for the first time in history. Court de Gébelin offered, of course, no historical evidence for his theory, nor did he have the ability to translate the ancient Egyptian texts to French in order to truly comprehend their teachings. But this didn't prevent him from perpetuating the notion that not only was tarot magical, but that its secrets were meant for and upheld by holy men. While we know that the cards did travel from the Middle East into Europe, the circumstances of that transfer as claimed by Court de Gébelin were false. In fact, modern tarot artist and expert Robert Place claims that it is impossible for tarot cards to have originated in Egypt since ancient Egyptians used

papyrus rather than paper. The long fibers of papyrus lent themselves best to lengthy scrolls rather than small cards, because if cut into small pieces, the edges would fray and wouldn't be suitable for play.

Still, when we examine some of the societal changes happening during this period of ancient history, perhaps we might deduce that Court de Gébelin's findings were not so random after all. While he made false claims tying tarot to ancient Egypt, we can make some space to appreciate a real ancient Egyptian icon who explored occult practices and was known for her unconventional spiritual beliefs. Although she isn't linked to tarot, Nefertiti's legacy is one of mystery and rebellion, similar to the many mystical women who followed in her footsteps. When we review mystics from the past, it only feels right to start at the very beginning, with the ancient spiritual pioneer Nefertiti.

Nefertiti

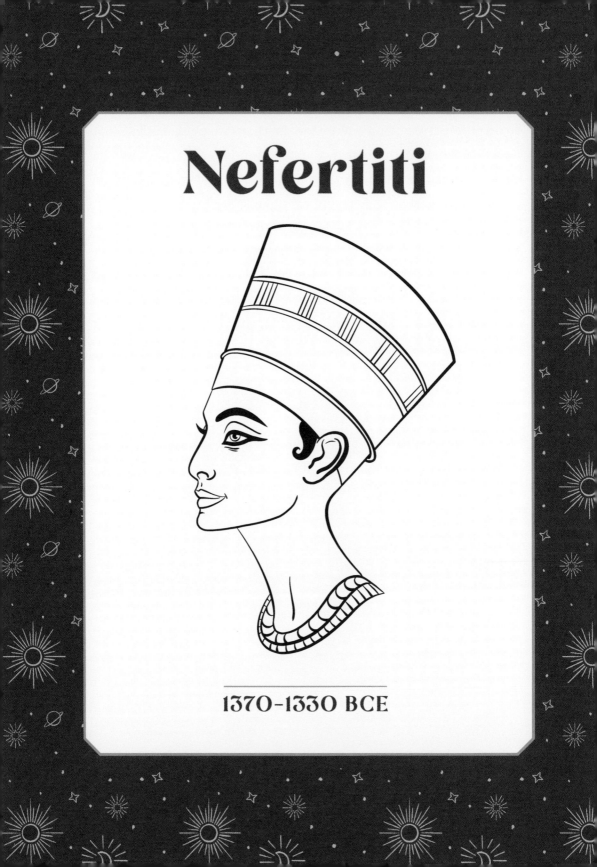

1370-1330 BCE

Many people have heard of Nefertiti and her mysterious rule—at the very least in connection with her stepson Tutankhamun and his fabulous treasure. After all, she is the most famous royal of ancient Egypt and has been a symbol of feminine beauty in the Western world since the early 1900s. However, there is much more to her story than one might expect, especially when it comes to spirituality.

Nefertiti was married to Pharaoh Akhenaten, who ruled Egypt c. 1353–1336 BCE. She gave birth to six daughters and was long believed to be Tutankhamun's mother. However, genetic testing has challenged this theory, and scientists believe that Akhenaten fathered the child with another wife.

Prior to Akhenaten and Nefertiti's rule, ancient Egyptians maintained polytheistic beliefs, honoring many gods and deities. The two fostered a significant religious shift during their reign, pushing society toward the worship of one true god in the form of Aten, a sun deity. They introduced the cult of Aten, or Atenism, which was devoted to the worship of the god in artwork as a circular sun with rays extended outward. The cult viewed Aten as the wellspring of all life, and its activities revolved around sacred rituals; plant, food, and animal sacrifices on open-air altars; and the creation of artwork and statues to honor Aten. The royal family was deeply ingrained in the worship of Aten and invested in spreading the beliefs of the cult, going so far as to build an entirely new city called Akhetaten (today's Tell el-Amarna), which would serve as the epicenter of the practice and included sprawling temples dedicated to Aten. In the new city, Atenism was declared the official religion of Egypt, and the pharaoh and his wife donned new titles to reflect their spiritual rebirth.

A notable element of the Aten cult was that it allowed Nefertiti to step into power not only as the pharaoh's wife, but as a religious leader. She took an active role in promoting the religion and became a priest of Aten during a time when women normally wouldn't be accepted into such positions. Her royal position became entwined with her religious power, making her quite an unconventional spiritual icon in Egyptian history, as she performed ritual acts that ordinarily only a pharaoh could do. In excavated artwork from tombs and statues of the period, Nefertiti is often depicted next to her husband or shown as a prominent figure in her own right. Aten, Nefertiti, and her husband were often portrayed as a sort of divine trio, suggesting that the royal family held a holiness on par with the god and that they were a direct link to the divine. The cult also elevated the status of many royal women, who acted as mortal embodiments of goddesses, with Nefertiti holding the divinest power of them all. In many tomb paintings, Nefertiti is featured in her priest role without her husband, making sacrificial offerings to Aten.

Throughout history and still today, many people have recognized Nefertiti for her beauty—a stone bust of the queen on display in the Neues Museum in Berlin, Germany, for example, has been one of the most popular ancient Egyptian relics since the 1920s. The statue depicts the queen with perfectly lined eyes and a towering blue crown. But this is more than just a statue of a beautiful ruler. It's said that her eyeliner acted as a talisman for spiritual protection, and Nefertiti sought out special ingredients to make her makeup more effective for warding off evil.

After Akhenaten's death and before Tutankhamun came into power, many scholars believe that Nefertiti may have ascended the throne under the name Neferneferuaten. Under Tutankhamun's reign, the royal family relocated to Memphis and abandoned Akhetaten, and the temples and remnants of the cult of Aten were destroyed in subsequent regimes.

While there is no record of Nefertiti's death and her tomb has never been discovered, it's clear that her spiritual power also garnered her massive political influence while she was alive. Seen as a link to Aten as a mortal fertility goddess and an influential priest, Nefertiti's holy influence helped change the religious beliefs of an entire nation.

Although with our greater understanding of history we can see there is no through line directly connecting Nefertiti and tarot, tarot's associations with ancient Egypt established by practitioners in the 1700s as well as Nefertiti's mystical power give this ancient queen a place in our list of mystical women.

While Americans were fighting the British during the Revolutionary War, a wider spirit of rebellion was echoing throughout the whole of the Western world. Freedom of ideas, challenges to religion, and efforts to break away from a monarchical society bubbled at the surface of French intellectualism, leading to the Age of Enlightenment. European class structures were changing, and with the feudal Dark Ages now behind them, people wanted more power for the masses rather than one royal family at the top of the social and political hierarchy. Essentially, the royal patriarchal power dynamic, at least in government, was being replaced with science, philosophy, and logic. As an offshoot of these values, scholars became enchanted with the teachings of ancient Egypt, perhaps in an effort to keep some sense of exclusivity around their knowledge. Antoine Court de Gébelin completed a book that glorified societies of the ancient past and viewed them as part of a golden age to which his contemporaries should aspire. This book, *Le Monde Primitif* (The Primeval World), studied by influential men throughout Europe and North America, further asserted his theory that tarot was connected to ancient Egypt. The mystique of tarot

cards was building, and with the help of Court de Gébelin, their fictitious magical origin was beginning to replace the perception of the cards as simply a game. People began to view tarot as a tool for uncovering ancient wisdom and secrets— and as a means to tell fortunes.

Simultaneously, secret societies began to develop in the scholarly circles that grew out of the now outdated medieval craft guilds. In these circles, the study of ancient Egyptian knowledge often played a role. Only men were allowed to join, and the exclusivity of the secret societies gave members a sense of power and elevation in a culture that was attempting to become more egalitarian.

These clubs assumed the arcane practice of tarot—rather than using the cards for simple games—as a right afforded only to them as a reward for their high status. Through the connections to ancient Egypt these secret organizations established, members perceived it as their privilege to adopt tarot as their own.

Within a few years, French occultist and fortune teller Jean-Baptiste Alliette, known by his pseudonym "Etteilla," had developed and published a technique for reading fortune-telling cards, thus establishing a standard of reading for the first time. Although cartomancy may have already been practiced in other parts of the world such as Russia, Etteilla seized the chance to be the first to publish instructions on how to use tarot cards. While perhaps a bit of an opportunist—his level of belief in fortune-telling is debated—he brought tarot out from under the curtain of secret societies. And by offering instructions on reading cards, he ultimately democratized them for the masses. Etteilla developed his own deck in 1789, followed by another in the late 1800s—the Grand Etteilla Tarot, which became the first known deck specifically created for the purpose of divination.

It's easy to see why the evolution of tarot did not include any significant female historical figures prior to Etteilla's contributions. Trading, elitism, wealth, class, secret societies, and academia were all catalysts for the development of tarot cards, and these were

all places from which women were traditionally excluded. In the late 1700s, though, we see the scales begin to tip, with Marie-Anne Lenormand becoming the first woman to significantly change the course of tarot.

Marie-Anne Lenormand

1772-1843

Marie-Anne Lenormand

Born in 1772 in Alençon in the Normandy region of France, Marie-Anne Lenormand was orphaned at a very young age. Her mother's death, followed shortly by her father's, resulted in stepparents taking over the care of six-year-old Marie-Anne and her two siblings. The young girl was said to be temperamental and disobedient, prompting her guardians to eventually relinquish her care to the nuns at a Benedictine convent.

It wasn't long after being sent to the convent that Marie-Anne began to show signs of clairvoyance. She was able to make prophetic predictions for her classmates, many of which would actually come to pass. She even accurately foretold that a nun discharged for wrongdoing would be replaced by a new nun selected by the king of France. Her premonitions prompted punishment and retribution from the nuns in charge. Her prophecies were interpreted as mischief by her elders, and the young child was disciplined with a meager diet of bread and water.

When Marie-Anne was fourteen, her stepmother could no longer financially support her private Benedictine education. As a result, Marie-Anne was instructed to support herself as a seamstress's apprentice. But with no talent or patience

for tailoring clothing, the young, rebellious teen packed her bags and set out for Paris on her own. It was around this time that Marie-Anne allegedly received her first tarot deck from Romani travelers. After finding out how to read the deck from them, she became immersed in the fascinating world of cartomancy, though she still had a great deal left to learn.

She found employment in Paris as a salesclerk and learned arithmetic. With that knowledge, Lenormand began to view numbers in a different light, becoming very interested in what kind of meaning she could glean from them outside of mathematics. This intrigue later played a role in her ability to read cards and explore numerology. Her calculating skills also secured her a mentorship in London with Franz Joseph Gall, a doctor who founded the very problematic pseudo-science of phrenology. Phrenology involved the study of the brain and the incorrect assumption that the shape and size of one's skull could predict personality traits. Nevertheless, the German physician was gaining a lot of traction for his practices at the time, and he was impressed by Lenormand's intelligence. He proclaimed that she was to be a great oracle and agreed to use his fame to help her secure new clients to launch her prophetic business. It's unclear how involved the budding young fortune teller was with the practice of phrenology, but it appears that she willingly took Gall's contacts and then moved on to build her own clientele.

Upon her arrival back in Paris in 1790, Lenormand got a job with a royalist before opening a shop of her very own on the wealthy Rue de Tournon. Here, her salon offered

fortune-telling, card reading, and a bookshop, where she worked full-time and gained popularity—and notoriety—for her abilities. It became routine for Lenormand to find herself held in jail overnight, with the police and the general public always a bit skeptical of her occupation. But she would always be released the next morning.

To understand Lenormand's rise to fame, it's important to consider the political and cultural climate of France in the late 1700s and early 1800s. The French Revolution stretched from 1789 to 1799, comprising ten years of great change coupled with unrest, violence, and upheaval. The spread of new ideas that ultimately led to democracy also came with public executions, poverty, and an economic depression. What's now known as the Reign of Terror stormed through the nation as leaders attempted to weed out counterrevolutionaries, culminating in nearly 17,000 executions. People were scared, hungry, unsettled, and looking for guidance. Keeping this in mind, it's easy to see why Parisians—especially members of the upper class and nobles—came to Lenormand for answers.

Through cartomancy, astrology, palmistry, and other methods of divination, Lenormand sought to establish fortune-telling as a science, and she was very judicious about how certain practices would be regarded by the public. It was when she foretold the beheading of King Louis XVI in 1793 and the fall of the monarchy that she really began to cement herself as a reliable and respected source of information. Raised by royalist parents, Lenormand was loyal to the monarchy and even allegedly sought to save Marie Antoinette from the

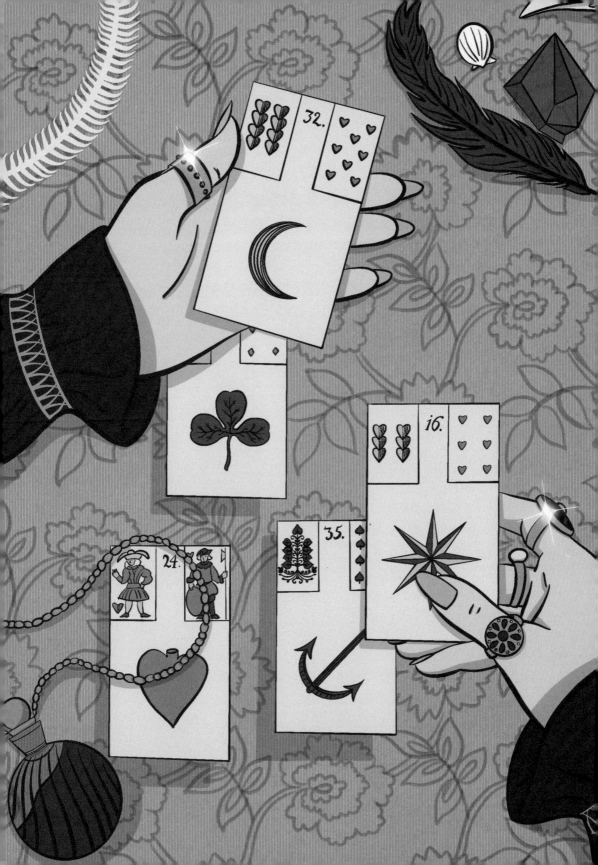

same fate as her husband. By disguising herself as a maid delivering a basket of fruit to the imprisoned queen, Lenormand was admitted into the prison where Marie Antoinette was kept. However, the queen of France was too shocked and afraid to run and ultimately faced her own execution nine months after her husband's. Lenormand seemingly emerged unscathed from the attempted jailbreak, except for a brief stint in prison.

As she continued to practice fortune-telling, Lenormand established herself as an oracle for people of all walks of life, but especially for the French noble class. She was a secret source of stability for the wealthy, who, at this chaotic time in history, feared for their lives and positions in society yet needed to maintain an air of external confidence. Whether they heeded her advice or not, Lenormand's chamber was a source of comfort for those who felt death on their doorstep.

Lenormand eventually became the personal tarot reader of Napoleon I's wife Joséphine Bonaparte. Their relationship began before Joséphine was crowned empress, when she was still just a wealthy young aristocrat in need of divine insight. Though Joséphine and her first husband were being targeted as enemies of the revolution, Lenormand assured her that she would survive the guillotine and go on to marry a soldier who would achieve great success—her husband's outlook was not so rosy. Two years later, Joséphine found herself married to Napoleon and on her way to becoming the empress of France. With this accurate prediction behind her, Joséphine's confidence in her fortune teller grew, and she continued to seek

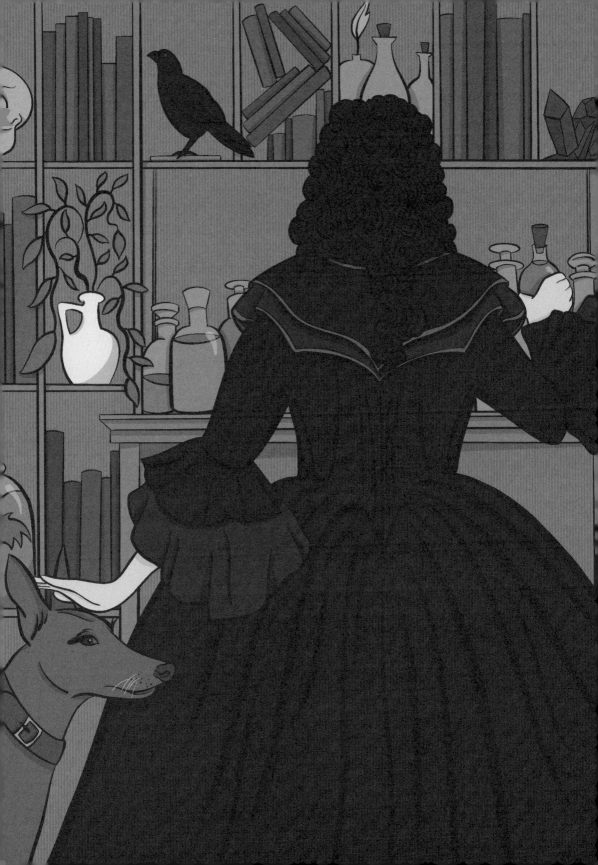

counsel from Lenormand, who is said to have predicted the royal couple's divorce, as well as Napoleon's ultimate collapse—much to the emperor's disapproval. Her interference in the royal relationship led to another stint in prison, a punishment to which she was no stranger by this point.

Though she remained active for several more decades and built quite a reputation, Lenormand eventually retired. During her later years, she still conducted secret readings out of her bookshop on the Rue de Tournon, where she welcomed clients with a variety of needs. She is said to have embodied a slightly unsightly charm as she aged—very petite with intense eyes, a blonde wig, and an intimidating mystique. Some say her reading chambers were decorated with taxidermied animals, reptiles preserved in bottles, and skeletons, all of which evoked an occult vibe that surely set the mood for her wary clients. Strangely enough, others describe the room as free from cliché or superstitious decor and quite bare.

Lenormand resisted the most common path for women at the time, choosing to never marry or sacrifice her career to bear children. In her older age, she is said to have adopted her sister's two children, after her sister had passed away and she herself had amassed enough wealth that she could ultimately leave a fortune to her nephew. Over her fifty years working as an oracle for the people of France, as well as clients who came to see her from across Europe, she was dubbed the Paris Sibyl. While it's important to remember that many of her stories of success come from her own writing—and therefore we must take them with a grain of salt—it's clear that Lenormand paved the way for

many female fortune tellers to come. During her lifetime, she was both respected and hated, but regardless of how people viewed her personally, her impact was indisputable. She wrote thirteen books chronicling her experiences, advised countless patrons, and made clairvoyant practices more accessible to the masses. After her death in 1843 at the age of seventy-two, her legacy as Paris's first female celebrity card reader inspired the production of the Lenormand deck. This iconic deck bearing her name remains in circulation today. The reading of such decks is a bit different from our standard tarot cards, yet they are part of the same family of card divination.

fter Marie-Anne Lenormand's death, tarot and fortune-telling became more popular and accepted in nineteenth-century Europe. After the revolutionary era ended and as politics and culture began to shift again in France and throughout the continent, cartomancy was no longer seen primarily as a cryptic, elitist game. Instead, it was viewed more as a leisurely activity that women could enjoy in each other's company. Card reading and street fortune-telling were new ways that women could earn money to support themselves and represented a job that women could pass on to other women. As women began to adopt the practice of card reading, the upper classes started to reject it as a lady's game that was not to be taken seriously.

Well after Marie-Anne Lenormand's death in 1843, Etteilla's influence reemerged with the posthumous publication in 1890 of his deck *The Grand Etteilla* by the French publisher Grimaud. With this project, we see a tarot deck that was meant for divination hitting the mass market—and becoming something more easily obtainable by ordinary people. Someone interested in a deck no longer had to hope to inherit a rare hand-painted one from wealthy family members. The deck combined the ancient Middle Eastern influence of Mamluk cards, the Italian *tarocchi* style, and Etteilla's unique spin to create something that could be used as a tool for magic.

Following the introduction of this deck, tarot's popularity declined for a few decades until the rise of mystically inclined secret societies in the Western world. That did not mean, however, that all related practices were abandoned. Although

tarot faded from the popular imagination in the 1800s, the adjacent practice of Spiritualism, or communication with spirits from the afterlife, was at its peak. Emanating from Scandinavia, Spiritualist teachings spread throughout Europe and, by the 1940s, to the United States, with many practitioners being women. One such woman, named Harriet Wilson, was doing very interesting work with spirits in New England.

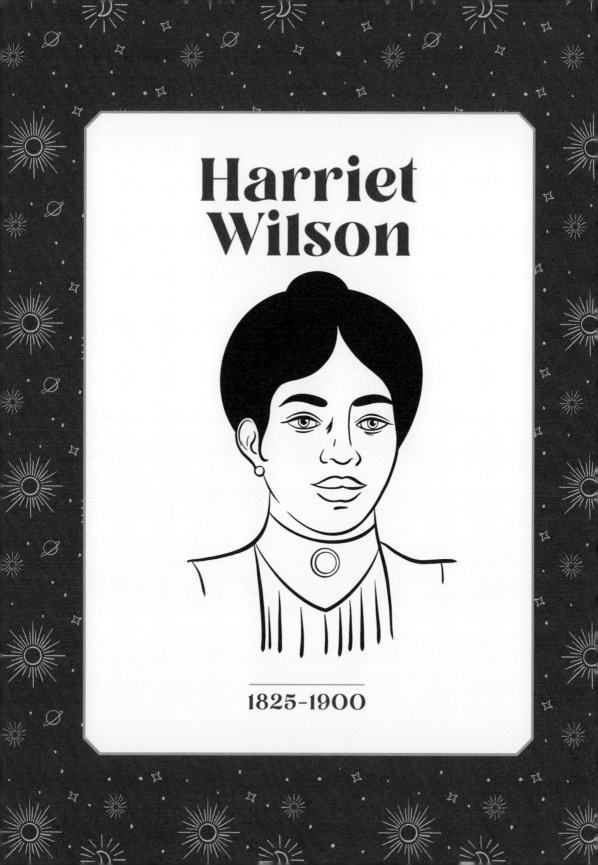

Harriet Wilson

1825-1900

Born on March 15, 1825, in New Hampshire, Harriet Wilson was an important figure in the Spiritualist movement. She was of African, Indian, and Irish heritage, and became an indentured servant at a farm after being orphaned as a child. Her early life was full of loss, mistreatment, and financial strife—hardships that perhaps led her to explore her spirituality later in life.

In 1859, Wilson wrote and anonymously published a novel, making her the first Black woman in American history to do so. The story, based on Harriet's experience as a free woman, shows that she was not *truly* free from the shadows of slavery and the cruel treatment of Black and mixed-race indentured servants that was so common.

While working as a servant through her thirties, Wilson became involved in Spiritualism and gained recognition for her clairvoyant abilities. She began to lecture large audiences alongside the most well-known Spiritualists of the time, discussing not just the spirit world and trances, but also advocating for women's rights, education reform, abolition, and workers' rights.

Wilson worked as a healer and psychic medium and stated, "the spirit-world is not afar off, in space, but here in our midst; and spirits are not bodiless beings but are with us in our homes." Her accomplishments spanned twenty years and included establishing two Spiritualist societies in Massachusetts, as well as a school for the children of the Spiritualists, which she dubbed the "First Spiritual Progressive School." She refused to hide her work as a medium from the children, often entering clairvoyant trances and channeling messages from the spirit world to her pupils. Her work as a Black teacher for white children was extremely uncommon at

the time and a testament to both her fearlessness and her passion for education. Eventually, her race and unconventional teaching methods resulted in her dismissal from her post and her replacement by white male instructors. She spoke openly about the abuse she received from colleagues and was ultimately pushed out of the Spiritualist movement as a result.

Disenfranchised yet steadfast in her beliefs, Wilson continued to conduct clairvoyant readings from her home in Quincy, Massachusetts, until her death in 1900 at the age of seventy-five. Her life's work speaks to an important period of American history—one in which a person could suffer unspeakable trauma as a result of their race and class yet still be considered "free." Despite the hardships she endured, Wilson went on to accomplish incredible things, with Spiritualism remaining a constant that gave her a sense of purpose in post–Civil War America.

Alongside Spiritualism, secret societies grew in popularity among esoterics throughout the late 1800s. These organizations slowly began to adopt tarot as an exclusive practice—one that only members were allowed to be initiated into. Higher-ups in these societies spread the false notion, stemming from Antoine Court de Gébelin's teachings, that the cards held ancient Egyptian power. Most of these organizations did not allow women members, perhaps offering a way for working-class men to maintain a feeling of importance in an increasingly democratic society. Though some of these organizations had already existed for some time—developing out of medieval craft guilds—the emergence of the Theosophical Society in 1875 represented a momentous age of secret societies, the popularity of which held strong until the early 1900s. Interestingly, though, given the general male domination within secret societies, the Theosophical Society was more open-minded. In fact, this one was cofounded by a woman named Helena Petrovna Blavatsky.

Helena Petrovna Blavatsky

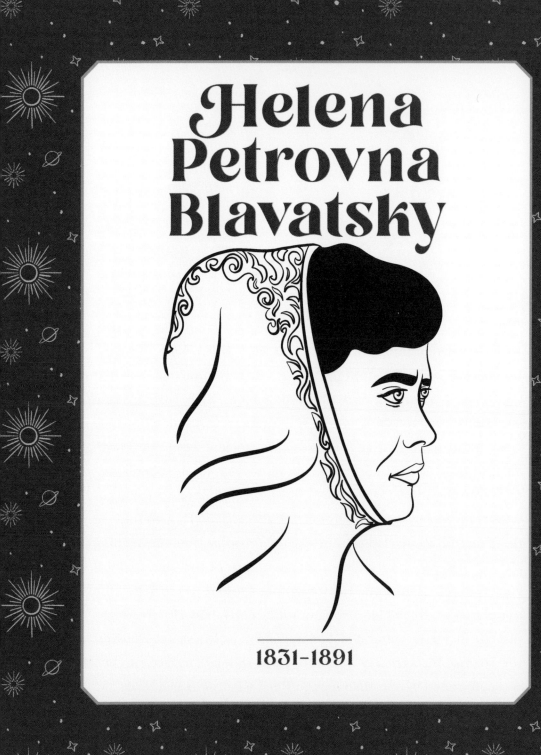

1831-1891

H elena Petrovna Blavatsky was a controversial figure in spiritual history—beloved by her followers and dismissed by her critics. She was born in Dnipro, Ukraine, in 1831 and developed an interest in magical studies in her teens. Helena married a much older Russian officer at the young age of seventeen but divorced him soon after the wedding. Enthusiastic about her newfound freedom, she set off on a series of international travels, meeting with spiritual teachers around the world. Some believe Blavatsky's travel stories were fabricated, while others claim that she spent this time working as a psychic medium in Paris and may have had a child out of wedlock. According to the woman herself, she went as far as Tibet, where she trained with religious scholars. After settling in the United States in 1873, she became a member of the Spiritualist movement and took up work as a medium, hoping to combine Western and Eastern practices.

Because of her specific experiences and goals, Blavatsky felt called to start an organization of her own. She founded the Theosophical Society in 1875 in New York City with fellow Spiritualist Henry Steel Olcott. Born out of Blavatsky's writings, Theosophy was essentially a new religion combining Western, Buddhist, and Hindu teachings. Many Theosophists believe that the spiritual masters Blavatsky had encountered on her travels communicated through her, making her a prophet. According to Blavatsky, Theosophy was "the synthesis of science, religion, and philosophy," and she continued to run the society in New York until relocating to Adyar, India, in 1880. In her new home, Blavatsky established the Theosophical Society headquarters and gained an international

following as the leading scholar of Theosophy. She and Olcott also became the first Westerners known to formally convert to Buddhism.

Blavatsky's reputation in India was damaged by allegations of fraud from within the Theosophical Society and the Indian press. Her mystical and psychic abilities were challenged by former members and colleagues, resulting in a private investigation and a 200-page report of her wrongdoings. The report itself has also garnered criticism for its potential inaccuracy. Whether the accusations and report's findings were valid or not, Blavatsky wasn't able to overcome the blow to her character. In failing health, she returned to Europe to spend her final days writing. She lived in Germany, then Belgium, and eventually died from influenza in London at the age of fifty-nine.

Blavatsky's legacy may be questionable, but one thing is certain: her work inspired Westerners to think beyond Christianity and explore Eastern spirituality. People in the West were searching for new means of spiritual fulfillment, caught as they were between modern society and the Christian traditions they had outgrown. Her writings exposed them to religions from Asia and Southeast Asia, and they hold a lasting impact even today.

Although Blavatsky isn't directly associated with tarot, her work through the Theosophical Society contributed to the overall growth of secret societies in the nineteenth century, as well as the rise of occultism—which did have a large impact on the evolution of tarot.

In the late 1880s, a Spanish-French scholar and hypnotist named Gérard Encausse became a member of many of the major occult groups, including the Theosophical Society, in order to study tarot, magic, and spiritualism. Encausse was known to his fellow occultists and scholars as "Papus." Though he ultimately became a physician, Encausse maintained his interest in the occult and authored a book under his pseudonym called *The Tarot of the Bohemians* in 1889.

His book was the first volume entirely devoted to tarot and was significant because it connected the cards to magic. In it, Papus made the claim that rather than originating in ancient Egypt, tarot was actually traceable to the beginning of humankind and connected to the biblical story of Adam and Eve. He mistakenly asserted that tarot inspired Middle Eastern playing cards, rather than the other way around. He would go on to author more books about tarot, focusing on its use as a tool for divination and fortune-telling. Though Papus's books were filled with falsehoods and he ultimately went on to write aggressive and problematic antisemitic texts under another pen name in the years preceding World War I, his books on tarot were translated into English and made their way into the libraries of secret societies across the United Kingdom.

While there were quite a few secret societies active across Europe and North America during the tail end of the nineteenth century, perhaps the most

notable one when it comes to the history of tarot is the Hermetic Order of the Golden Dawn. The Golden Dawn was an organization that originated in England in 1888. With a grounding in occultism, mysticism, and the supernatural, members delved into spiritual and magical studies, including astrology and tarot, as well as paranormal activity. The organization was comprised of three different Orders representing various tiers within a hierarchy. The top tier was made up of "Secret Chiefs," who members believed connected to a deeper realm of esoteric and cosmic secrets. While it was difficult to climb the ranks of the Orders, it was possible, and each tier offered more in-depth access to the areas of study of the Golden Dawn, including tarot. Most members at least had access to what was known as *Book T*, a secret book that compiled the work of previous tarot scholars to create a kind of master document connecting tarot to magic. The study of *Book T* created a strong tie between tarot and the ritualistic magic members of the club took part in, which led to a distinct and practical—albeit exclusive—purpose for decks. By this point, the cards had come a long way from their roots as simply diversions for the upper classes.

Moina Mathers

1865-1928

While women didn't have the same access to the teachings of the Order of the Golden Dawn that male members did, they were accepted into the organization, which was uncommon for secret societies at the time. In fact, the first member to be initiated was a woman named Moina Mathers, a talented artist and occultist who was married to Samuel Liddell MacGregor Mathers, one of the founders of the Golden Dawn.

She was born Mina Bergson on February 28, 1865, in Geneva, Switzerland, and was of English, Polish, Jewish, and Irish ancestry. Her parents were accomplished yet impoverished; her father was a gifted composer, who struggled to support his seven children. Despite her father's talents, the family wasn't spared the antisemitism ingrained in Europe at that time, and they moved often to find work for him as a musician and teacher. The Bergsons moved to Paris when Mina was a toddler and then later relocated to London.

It was still rare for women to be accepted into art school in the late 1800s, but the Slade School of Fine Art in London was one of the few exceptions. Mina showed early artistic promise and was taken on to study at the Slade at the age of fifteen, proceeding to earn a scholarship and several awards for her drawing skills. She continued to develop her practice and often referred to the artifacts at the British Museum for inspiration. It was there she met her future husband, Samuel Mathers, who was a twenty-two-year-old burgeoning occultist and writer. The two felt an immediate connection—that of soulmates—and were married in 1890, much to her parents' disapproval. They'd hoped for a financially secure future for their daughter, and Samuel didn't necessarily have a stable income. However, as Mina began to explore her own

clairvoyant abilities and Samuel's spiritual interests grew, the two became closer and closer. She changed her first name to Moina after the wedding, and the two became inseparable partners and collaborators.

Samuel had established the Order of the Golden Dawn in 1888—the year after he met Moina—with two other founders, and Moina was the first person he initiated into the organization. In fact, it was through her longtime friend Annie Horniman that the founders received financial backing for the Golden Dawn. Although it was her husband who opened her up to the world of the occult, many say that Moina Mathers was the backbone of the organization. While her husband worked to summon spiritual forces, Mathers would act as a clairvoyant and use her artistic skills to illustrate and give life to his visions. She became the primary seer for the whole organization, practicing mediumship and divination. Mathers was also responsible for creating all the visuals that accompanied the rituals for the Inner Order—the group of the most studied members—as well as designing the interiors of the temples and costumes for various magic rituals. For several years, the Golden Dawn seemed to orbit around the couple, and especially Moina as its priestess. At the time it was believed that Mathers had mastered her psychic abilities and could even perform astral projection, or the act of transporting one's consciousness to spiritual realms while the body stayed on earth. And according to tarot scholar Mary K. Greer, she may have even created the artwork for the original Golden Dawn Tarot deck, which some say was later appropriated and credited to a man.

The couple moved to Paris in 1892. There, Mathers remained loyal to Samuel despite the tumultuous time of scandal and feuding within the Order that ensued. In 1900, the members of the Order in England rebelled behind Aleister Crowley and pushed the couple out of the Order. The couple responded by forming their own group, called the Isis Temple, with their followers in Paris. In 1918, Samuel died, and Moina moved back to London to become the leader of the Alpha et Omega, a faction of the Golden Dawn the couple had previously founded. As Imperatrix of the Alpha et Omega Lodge for nine years, she continued to try to communicate with the spirit realms as she struggled financially and attempted to profit from sales of her artwork. She died in 1928 at the age of sixty-three after experiencing declining health and refusing to eat. Mathers's efforts made a strong contribution to the occult revival in Europe, and her unconventional life's work was the embodiment of female liberation—or perhaps the closest one could get to it in an exceedingly male-centric society.

As the American Civil War was coming to an end and with World War I right around the corner on the global stage, it makes sense that communing with the dead, thinking about the afterlife, and desiring to understand the future would shape the cultural zeitgeist. The popularity of tarot and occult practices generally has clear ties to social unrest and wartime—the moments when people need answers the most. But Europeans and U.S. citizens weren't the only people to look to magical sources for answers during troubling times. In fact, one woman who became a spirit guide and healer for her people in the late 1800s would end up deeply entangled in politics in the years before the Mexican Revolution.

Teresa Urrea

1873-1906

In 1873, Teresa Urrea was born to an indigenous teenage mother, Cayetana Chávez, in Sinaloa, Mexico. Her father, Tomás Urrea, was the successful owner of the ranch on which Chávez worked. When Teresa was in her early teens, her mother disappeared, after which her father decided to relocate to Cábora, Sonora, a remote Mexican town, with his fifteen-year-old daughter. Since he was someone with liberal political ideals, this was a strategic move to avoid the notice of the conservative, dictatorial Porfirio Díaz presidency.

The young Teresa's life was suddenly full of magical occurrences. She began studying medicinal herbalism through an apprenticeship with a local indigenous healing woman, or *curandera*. She fell into a coma at the age of sixteen and was presumed dead. However, she regained consciousness at her wake, shocking her family, and then entered a trance. Several months later, she awoke from her trance with the newfound ability of healing people with a touch of her hand. Rumor quickly spread of the young woman's healing gifts, and people traveled to her to be cured of their ailments, earning her the title *La Santa Teresa*, or *Teresita*. She became active in her community, serving the impoverished and ill and encouraging people to channel their spirituality outside of the church. Urrea is also said to have predicted natural disasters and to have exhibited psychic abilities.

At this point in Mexican history, tension was growing between the indigenous farmers—including the Tarahumara, Yaqui, Mayo, and Tomochic—and Díaz's government, which was violently forcing them from their inherited property to make room for industrial agriculture. Teresa Urrea became a spokesperson for these communities, fighting for their autonomy and equality, and speaking

out about the injustices they were facing. The combination of perceived holiness and political rebellion that Urrea had developed made her an enemy of both church and state. After a rebellion broke out in Tomochic—during which soldiers descended upon the village and brutally slayed 300 innocent people—Urrea was blamed and deported from her home. When she was nineteen years old, she and her father fled to the American Southwest, surviving assassination attempts and ultimately settling in Arizona.

Urrea's following continued to grow, with several Mexican uprisings occurring in her name. She had become a symbol of justice for her people and continued to work as a healer and mystic. Her spiritual work was entwined with her political influence for the rest of her life, garnering her recognition as a modern folk saint. After having two children, however, she lost a significant number of followers because her perceived virginal status was disrupted. She died at the age of thirty-three of tuberculosis, and though her status was somewhat diminished at the end of her life, her legacy has since been elevated to a position of mystical sainthood.

According to writer Luis Alberto Urrea, Teresa Urrea's rise from folk saint to religious legend was not entirely unusual. It seems that the hardships of the Mexican Revolution created pathways for people to seek out spiritual guidance and healing. Many rebels gained a saintly status for speaking out against oppression or for being wrongly mistreated. The difference with Urrea, however, is that it was rare for a woman to become so beloved. Additionally, her healing and psychic powers set her apart from her male counterparts, and she is often remembered today as the Mexican Joan of Arc.

Back in Europe, the Golden Dawn's study of tarot represented the collective yearning for answers that suffused this period of history. Another remarkable woman became a member of the Golden Dawn in the early 1900s, and she would be responsible for what was perhaps the most significant moment on tarot's timeline. Pamela Colman Smith, or Pixie as she was often known, changed the way tarot could be accessed by collaborating on a brand-new deck designed for consumer usage: the Rider-Waite-Smith deck.

Pamela Colman Smith

1878–1951

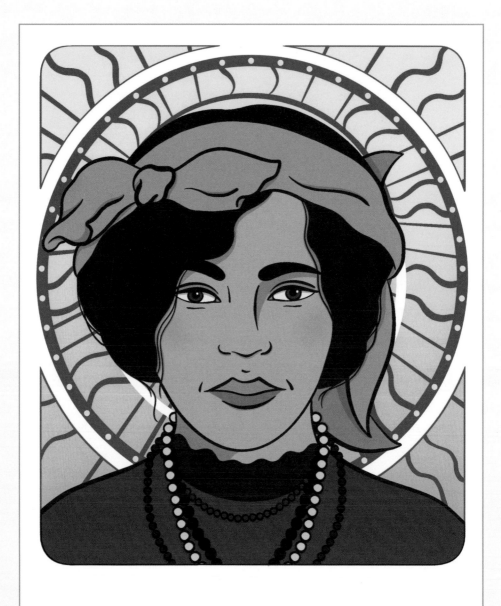

Pamela Colman Smith

Pamela Mary Colman Smith was born in the town of Middlesex, England, on February 16, 1878. The child of American parents, young Pamela resided first in Chislehurst, followed by Manchester. During her early childhood, she was exposed to the ideology of the Manchester Society for Women's Suffrage, a noteworthy group that led the fight for women's rights in the region. Although she was just a girl, spending time in such a political climate may have influenced her passion for equality, which carried into her later life.

When Pamela was ten, the family crossed the Atlantic to reside in Brooklyn, New York, and they continued to move around for the next decade or so. They traveled primarily between England, New York City, and Jamaica, which was uncommon for the time. As a merchant, Pamela's father was often called to travel for business, and his wife and daughter followed him on international trips by sea for long periods of time. When they were at home in Brooklyn, the family's household brimmed with music, art, and liveliness, as both parents held a deep appreciation for the arts, particularly theater. It's believed that Pamela's mother, Corinne Colman Smith, was of Jamaican descent, and her father was of European

ancestry, resulting in what some have theorized was a perception of Pamela as biracial. Due to her appearance and moving around so much as a child, she often felt out of place in social situations. She did, however, find community within the time's booming theater scene and often resided with caretakers who happened to be leading actors and creatives while her parents were away on business. This immersion in the world of theater was another lasting influence on Pamela, leading her to pursue stage design, costuming, and performance as an adult.

She showed quite a bit of artistic promise at a young age. Viewing her as quite advanced for a teen, Brooklyn's new yet esteemed Pratt Institute accepted her as a student in the art program when she was just fifteen. It was here that she explored the work of other artists, both past and current, and began to develop her own creative voice. She became fascinated by Japanese woodblock printing, and the influence of the bold lines and colors of this practice can be seen in the work she made as an adult.

While Pamela thrived in an academic environment, she was pulled from her studies prematurely when her mother fell ill. Before she could finish her degree, she dropped out and headed to Jamaica to care for her ailing mother and support her father.

With four years of school under her belt, however, the eighteen-year-old Smith embraced the new challenges of loss, relocation, and rediscovery. After her mother's death, she spent her time in Jamaica running a kindergarten and making

art, conducting puppet shows for the kids, and offering story-telling to her new neighbors and friends.

Five years later, Smith traveled back to New York to have her first art exhibition at the Macbeth Gallery, the pioneering commercial venue for American art in Manhattan.

By the time she had turned twenty-one, Smith had decided to permanently relocate to London, only traveling back to New York for special opportunities. It was a bold undertaking to make such a move alone, as a young woman without finan-cial support from her family and with the intent of building an artistic career. Her father passed away shortly thereafter, leaving Smith parentless yet motivated to build her own com-munity. Many of the close friends she hosted at weekly parties during this time would later become famous creatives, includ-ing the Irish poet William Butler Yeats, the American painter Alphaeus Cole, and the English writer Arthur Ransome. During a period made more difficult by grief and financial struggle, Smith also began to truly develop her identity as an artist and storyteller. She attracted interesting people and built a hub for them in her home.

Around the time that she moved back to England, Smith also began to explore occult studies. Perhaps she did so to make sense of the loss of her parents or to find a spiritual outlet during an uncertain time. She joined her friend Yeats in becoming a member of the Order of the Golden Dawn in 1902. The time Smith spent with the organization deeply impacted her artwork. She began to channel her occult stud-ies into her paintings and performances, connecting with the

supernatural world of mysticism. She would create illustrations for the *Occult Review*, a publication about all things mystical where she met fellow Golden Dawn member Arthur Edward Waite. Several years into her studies, Waite invited her to collaborate on a new tarot deck he was developing—known today as the Rider-Waite-Smith deck.

Waite was a poet and an occult scholar who had also spent his childhood split between Brooklyn and England, much like Smith, before ultimately settling in London with his mother. He became drawn to occultism at the age of twenty-one after the death of his sister, dedicating himself to his studies when he wasn't working odd jobs. At this time, most occultists were still using the Tarot de Marseille, but Waite set out to create a new deck with an accompanying guidebook. Waite is a bit of an infamous figure in tarot history. As a member of the Golden Dawn, he was expected to keep the teachings of the organization close to his chest. He broke that oath, however, by publicly revealing many of its secret principles in his writings. And since he had already exposed the classified information taught by the Golden Dawn, he decided to continue riding that wave by demystifying tarot. He wrote a guidebook called *The Pictorial Key to the Tarot*, which included the history of tarot and explanations of all the cards in the deck. At the same time, he commissioned Smith to create illustrations for all seventy-eight cards of the Minor and Major Arcana, which set his deck apart from previous ones that only focused on illustrating the twenty-two Major Arcana (with the exception of the Sola Busca deck).

Smith completed the job in less than six months for very little pay, almost certainly unaware of how impactful this project would be on the development of tarot.

Since women weren't allowed to draw from live nude models in art studios at the time, Smith had to find her own references for all of the figures in the tarot deck. She enlisted her friends to pose for her drawings and studied the architecture around her to inform the structures she depicted. She worked quickly to take Waite's instructions and synthesize them into a cohesive body of work, while also borrowing references from her own life to ensure her deck would stand apart from any other. It was the quick reportage style of drawing she had developed as a young artist by sketching actors in the theater that enabled her to complete so many illustrations in a short period of time. Plus, Smith had access to photographs of the Sola Busca deck at the British Museum in London—a place she could go frequently to study the decades-old images and draw inspiration from them. The new deck included elements from the Sola Busca deck, as well as from Christian iconography, Kabbalah, astrology, and the Golden Dawn's teachings of Hermeticism.

The deck that Smith and Waite created was the first consumer-facing deck on the market. It was sold to customers at an arts and crafts fair in London and soon after became available to tarot enthusiasts via order forms in the back of occult books and publications. These books were published by William Rider & Son, which led to the deck's original title of the Rider deck. Shortly after its first publication,

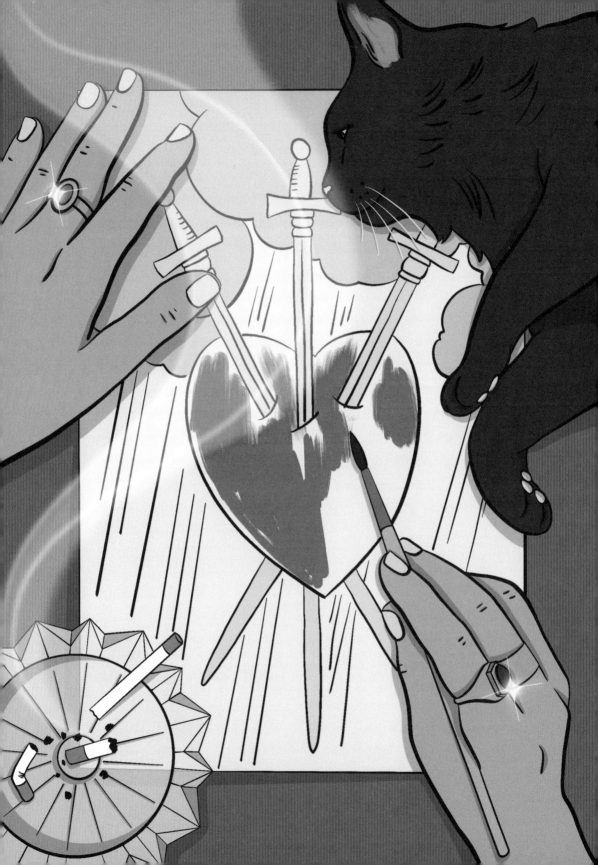

the deck was reprinted in full and retitled the *Rider-Waite Tarot Deck*, honoring Arthur Waite's contributions, but not Pamela Colman Smith's. Despite the many subsequent reprintings of the deck, the title was never formally updated to include Pamela's name. Fortunately, the artist placed her signature on every card in the deck—a black monogrammed PCS in the lower corner, establishing the lasting mark she made on the history of tarot. Today, many people call the deck the Waite-Smith or Rider-Waite-Smith deck to honor her legacy.

The narrative nature of each card illustration that Smith made, which allowed readers to interpret them freely while having the option to refer to the guidebook that Waite wrote, set the deck apart. Rather than depicting just a symbol for the Minor Arcana cards, she created a full scene with figures, landscapes, and rich symbology for every single one. In this way, Pamela essentially combined the trump cards from the earlier *tarocchi* game with the Minor Arcana, or the numbered suit cards. Through their work, Smith and Waite connected members of the greater society with the previously hidden, aristocratic knowledge of tarot. Tarot was no longer a practice reserved for the elite members of secret societies; rather, it could now be obtained and understood by anyone with the ability to read.

Although their collaboration was immensely impactful on the way people practice tarot, it wasn't a wholly positive experience for the two themselves. Waite was described by his peers as someone who maintained an air of superiority in his writing and teachings. He was critical of female artists and took credit

for the conceptual elements of the deck, asserting that he came up with the ideas and spoon-fed them to Smith. Additionally, he did not share any royalties earned from sale of the deck with the artist, meaning that Smith was robbed of the chance to continue earning income from the deck after her fee was paid.

Her financial life would remain unstable—a sad state of affairs that might have been somewhat remedied by sharing royalties with her collaborator. Just a few weeks after Smith completed the deck, the 1909 Trade Boards Act was passed, which established a minimum wage in the United Kingdom—another factor that would likely have guaranteed her more income for the massive project she'd just completed.

Smith's legacy does not end with the tarot deck. She later joined the London Suffrage Atelier, an artist collective that supported suffragettes through art and illustration. She taught art to fellow members and created posters and broadsides to further the cause. She also illustrated several books, including children's books, and earned the admiration of notable creators of the time, including the famed French composer Claude Debussy, *Peter Pan* author J. M. Barrie, and the German fine art publisher Berlin Photographic Company, which sponsored an exhibition of her work in New York City in 1912.

In 1911, Smith converted to Catholicism after exploring an array of spiritual and occult practices throughout her adult life. She continued to produce art, but became increasingly solitary in her later life—in contrast to her very sociable and connected younger years.

When she was thirty-six, Smith relocated to the Lizard Peninsula in West Cornwall, far away from her friends and studio in London, where she settled into isolation. She continued to navigate financial distress as she picked up work as a nanny and party performer. She was mainly focused on caring for her companion Nora Lake, a Spiritualist who suffered from post-traumatic stress from World War I. The two women lived together for decades, and although we don't know for certain, it is assumed that Lake was Smith's romantic partner. Smith never married, nor did she leave evidence of any intimate relationships with men, but instead, she resided with Lake and surrounded herself with women, including openly queer friends.

After a few moves throughout the United Kingdom, Smith ultimately settled in Bude, another seaside town in Cornwall, to be closer to Lake's relatives. Here, she continued to make art, never losing sight of her creative goals and ambition.

At the age of seventy-three, Pamela Colman Smith died of heart disease. She left her estate to Nora Lake, but this final wish would not be fulfilled due to the amount of debt she'd accumulated at the end of her life. The location of her burial site is unknown—she couldn't afford a cemetery tombstone, and local records of this time were destroyed by a fire.

U.S. Games Systems, Inc. reprinted the tarot deck with the title *Smith-Waite Centennial Tarot Deck* in 2009 for its 100th anniversary. The updated title obviously pays respects to Smith, yet the standard deck sold today is still named the *Rider-Waite Tarot Deck*. Regardless, her work on the deck changed the

trajectory of tarot, making it accessible to millions of practitioners around the world. When we consider that women's place in the history of tarot is complicated, it's so important to remember that it was Pamela Colman Smith, a queer, female artist of color, whose imaginative yet easily digestible drawings have had a defining role in the way we see tarot.

While the development of tarot and its main figures up to this point have been mostly centered in Europe, we see the secret societies and the occult revival make their way to the United States in the 1920s—and with these came tarot.

But before this occurred, Spiritualists like Harriet Wilson were developing a community of unconventional religious practices that became closely tied to abolition and women's rights. And while these abolitionist and Spiritualist beliefs flourished in the northern United States, the American South was also buzzing with its own kind of magic. The Southern population in the United States in the late 1800s and early 1900s was a unique composition of enslaved Africans, elite white slave owners, lower- and middle-class whites, and newly freed people of color. In New Orleans, French and Creole peoples additionally generated even more cultural melding. Spiritual practices among these groups merged and morphed, resulting in one particularly dynamic religion—New Orleans Voodoo. Voodoo is a combination of the rituals and beliefs enslaved peoples initially brought with them from West Africa. It was bolstered by the arrival of Haitians who fled to Louisiana after their revolution in 1791, and it combined with some elements of Catholicism. The beliefs of Voodoo practitioners were both different from and informed by the Catholic tenets held by the local population in Louisiana, leading to a distinctive tradition that was separate from its antecedents in both West Africa and Haiti.

In Voodoo, spirits from the afterlife are believed to interact with the living on a regular basis, in stark contrast with traditional Catholic doctrine. While different from tarot, Voodoo had a religious purpose as well as a societal one. It was the result

of an amalgamation of cultures, and it helped people of color create a sense of community and power in a foreign land through connection with the spirit world, and sometimes even opened up employment opportunities. Similar to tarot, Voodoo became a spiritual outlet that moved away from traditional European religious practices, offering guidance to practitioners during complex periods of great societal change. As Voodoo became synonymous with New Orleans culture, some practitioners became experts in their realm by channeling their ancestors, spirits, and nature and by positioning themselves as valuable spirit guides needed by society.

The most famous occultist and Voodoo queen of 1800s New Orleans was a multifaceted woman named Marie Catherine Laveau.

Marie Catherine Laveau

1801-1881

While Marie Laveau's birth date is a matter of debate, many scholars believe that she was born in 1801 to a French politician father and a mother of mixed Black, white, and Native American ancestry who was a free woman. Not much is known about Marie's childhood, although some speculate that her grandmother was a revered Voodoo priestess in Haiti and that her family lineage had strong spiritual ties. She was born approximately eighty years before Pamela Colman Smith, yet the complexities around biracial identity proved similar for both women.

At the age of eighteen, Marie married a refugee of the Haitian Revolution named Jacques Paris. The couple had two daughters, and Jacques worked as a carpenter to support their young family. Unfortunately, Jacques went missing shortly after the birth of their second daughter, only a few years into their marriage, and was later reported dead. Subsequently referring to herself as the Widow Paris, she went on to marry a French nobleman and give birth to several children, although the yellow fever outbreaks that took the lives of many Louisianans claimed many of her children as well, with only two of her daughters making it to adulthood. She also adopted children during the course of her life.

Laveau, a devoted mother, worked as a hairstylist to support her family. It was in her salon—where she serviced both white and Black clients—that she discovered an invaluable resource. Many of her Black clients worked as house servants for her upper-class white clients and could provide personal information about them. Laveau's clients often sought life advice from her, and as she used the intel their housekeepers provided to boost her guidance, she began to develop a reputation as a gifted advisor and conjurer.

Soon enough, Laveau was charging money for her advice and offering both white and Black customers protection from evil, individual guidance, spiritual ceremonies, and spiritual arbitration. Her client base included many noble and political people who came to her for help with their careers, troubles, finances, fertility, or romantic lives, which helped her achieve fame as *the* Voodoo Queen of New Orleans.

Even as Laveau made her living working with these wealthy clients, she provided support and counsel to those who couldn't afford to pay, as well as the sick and imprisoned. She was a proficient herbal healer, and in addition to prayer, she would offer medicine to those in need and would often send her clients home with a *gris-gris*, or a magical talisman in the form of an herb, powder, or candle that was believed to bring good fortune or keep evil at bay. In addition to private sessions, Laveau also conducted ritualistic gatherings of dance, spirit conjurings, and worship at her home and in public places throughout New Orleans. During these public demonstrations, white Louisianans would often secretly observe the ceremonies from afar, later delivering exaggerated tales of what they had seen and contributing to the negative or scary perception of Voodoo by outsiders.

Laveau eventually retired from practicing Voodoo professionally, spending her time caring for the sick and condemned until her death in 1881. Her passing brought with it a large decrease in Voodoo's popularity. At this time, the New Orleans population was becoming less dependent on older spiritual traditions, and although her daughter took on some of her mother's work, Laveau maintained her status as the last great Queen of Voodoo. To this day, her tomb in St. Louis Cemetery No. 1 remains one of the city's

most famous tourist attractions. Her legacy is not without its own complications, however, as many scholars believe that she herself owned slaves, as would have been common for a free person of color at the time. She is remembered as both a spiritual icon and a problematic slave owner, reflecting the profound complexities of race and class in the American South in the 1880s.

Each year on June 23, people gather at what is known as St. John's Eve, a public party started in the 1830s by Marie Laveau. Today's celebrants still participate in the head-washing ritual and festivities that she created almost 200 years ago—and included in the summer holiday cheer enjoyed by partygoers are tarot card readings.

While Laveau's methods were different from those of a tarot reader, people consulted her on the very same questions for which they often turned to the cards. With Laveau and her Voodoo practices, we see the effects of a chaotic society driving people to seek spiritual guidance, which are mirrored in the cyclical popularity we find with tarot.

The Rider-Waite-Smith deck helped bridge the gap between the elite communities that practiced tarot and the general population. As was the case with many occult practices, once more people gained access, the shell of exclusivity placed around it by the upper class began to break down. The work of Pamela Colman Smith and Arthur Waite was largely responsible for this development, and its effect wasn't restricted to the United Kingdom. In fact, not only was their deck and guidebook published in North America, but copycat decks also began appearing in the United States, furthering tarot's entry into popular culture.

After the Rider-Waite-Smith deck reached North America, a Chicago-based member of the Order of the Golden Dawn, Paul Foster Case, entered the tarot scene. In 1916, Case began to write articles on tarot, which were published in *The Word*. *The Word* was an occult magazine dedicated to magic and spiritual studies, and these articles brought the study of tarot to even more people. In 1920, Case published a book called *An Introduction to the Study of Tarot*, which to this day remains one of the leading guides to tarot for beginners. Because of its short length and readability, his book further demystified tarot for a broad audience, though in terms of using tarot for divination, Case's work still kept what he saw as the magic of tarot shrouded in spiritual studies—in this instance by asserting that one needed to understand astrology to use the cards.

Later, after a falling-out with the Golden Dawn and expulsion from the group by Moina Mathers, Case went on to start a new order of esoteric study in Los Angeles in 1923. He borrowed teachings from the Golden Dawn and named his organization the Builders of the Adytum (B.O.T.A.). While there, he continued writing about tarot and accepted members to study occultism. Through his many writings on tarot and

his teachings at B.O.T.A., Case positioned tarot within an overall concept of spirituality, which included astrology, Kabbalah, meditation, and other practices. In spite of these esoteric over- tones, these efforts continued to normalize tarot, much like Waite's *The Pictorial Key to the Tarot* had, but they still didn't provide a clear set of instructions for using the tarot cards for divination—which many Americans were yearning for.

While the European occult practice of tarot spread to the United States and took hold with many constituencies during the early twentieth century, it's important to note that African American people had developed their own spiritual practices that were outside of conventional organized religion. Though often mistakenly confused with Voodoo, Hoodoo is a separate belief system that originated in the American South within the African diaspora. This unique melding of African spirituality and Christianity developed as a result of the forced conversion of millions of enslaved peoples to Christianity by European colonialists and slaveholders over the course of hundreds of years. While Voodoo worships specific spirits and deities and is an organized religion, Hoodoo allows for the freedom to praise any gods that one chooses and is more focused on the natural environment. Originally preserved and practiced

by Black communities as a way to heal from the horrors of slavery and resist white oppression, Hoodoo, also known as rootwork, is still a means of conjuring safety, connection with ancestors, and spiritual identity for many people today. In the 1920s and '30s, one woman committed herself deeply to the study of Hoodoo and surfacing the experience of Black Americans.

Zora Neale Hurston

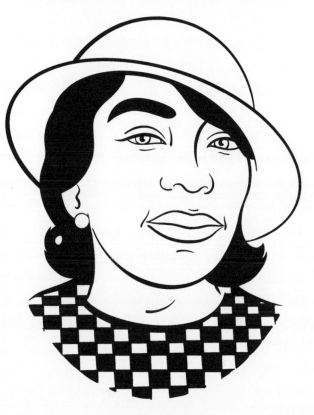

1891-1960

*Z*ora Neale Hurston is known foremost as an author, but she was also an incredibly accomplished anthropologist, researcher, playwright, and filmmaker. She is perhaps the most prolific and celebrated Black woman author of the early twentieth century.

Zora was born into a family of ten on January 7, 1891, in Notasulga, a very small town in rural Alabama. Her mother worked as a teacher, and her father was a carpenter and Baptist preacher. Zora was three years old when her family relocated to Eatonville, Florida, where she spent the remainder of her childhood. For several years, Eatonville had been established as one of the first self-governing, all-Black towns in the United States. Free of white citizens, Eatonville provided residents a unique living experience for the time period—one outside of white control, at least on a local level. Within a few years, Zora's father had been elected mayor of the town, which elevated the family's social status. The beauty of Eatonville for a young and energetic Zora was the ability to see people who looked like her occupying all levels of society, giving her a sense of community, cultural affirmation, and achievement.

When Zora's mother passed away in 1904, the thirteen-year-old was sent to boarding school in Jacksonville, Florida, where her life changed radically. In Jacksonville, the young girl was no longer part of a community where she fit in culturally. Instead, she became uncomfortably aware of her race amid her white classmates and felt isolated. These contrasting experiences would later inform her writing, as she reflected on what it meant to be a Black woman in early 1900s America. Her father remarried, and Zora and her new stepmother had a volatile relationship. After some years, Zora's

father and stepmother ceased tuition payments to her school, and she was discharged from her studies.

At the age of twenty-six, after holding a series of odd jobs and struggling to make ends meet, Hurston was eager to finish high school and enroll in college. She moved to Baltimore and pretended to be sixteen in order to apply to Morgan College, a public high school affiliated with Morgan State University. Hurston went on to attend Barnard College to study anthropology, graduating in 1928 at the age of thirty-eight. In the years that followed, she carved out her place in American literature, going on to study at Columbia and publish four novels, several essays and short stories, an autobiography, plays, and two books of folklore. Her most celebrated novel, *Their Eyes Were Watching God*, came out in 1937 and was an exploration of the life and development of an American Black woman.

In 1931, Zora published "Hoodoo in America" in the *Journal of American Folklore* after years of traveling through the South and collecting notes about African American folklore. She studied the work of Marie Catherine Laveau and her successors in New Orleans and got her information directly from practitioners, becoming their student and undergoing rites of passage and initiation ceremonies. Her research was more than an anthropological study— it was a detailed, firsthand account that provided the world with a true understanding of Hoodoo. With respect and authenticity, Hurston's writing countered the stereotypical accounts of Hoodoo that white journalists had previously offered.

Hurston was then awarded a Guggenheim Fellowship in 1936, which allowed her to travel to Haiti for six months and immerse herself in Voodoo practices. Once again, she earned the trust of

local spiritual practitioners and learned about the complexities of the religion for herself. Her research culminated in the publication of *Tell My Horse*, a book summarizing all the layers of her learnings without sensationalizing or exploiting the people she had encountered along the way.

Despite Hurston's many contributions to the world—and like many accomplished women before and after her—she never reaped financial benefits from her career. When she died in 1960, after suffering a stroke, she didn't leave behind enough funds to cover the cost of her funeral or burial. As a result, Hurston was laid to rest in an unmarked grave. In 1973, a young Alice Walker, inspired by Hurston's life and writing, set out to honor the magnificent woman and traveled to Florida to purchase a headstone for her role model. She chose the epitaph "Zora Neale Hurston—A Genius of the South."

Just as tarot's spread throughout Europe and the United States continued to build, the notorious magician and writer Aleister Crowley was building his reputation in England as one of the most influential occultists in history—as well as quite a misogynist, bigot, and generally problematic person. While Crowley's life and work in the magical realm extends far beyond tarot, it is his writing for a new deck in the 1940s that ties him to this particular story.

Crowley's deck, known as the Thoth deck, was meant as an alternative to the Rider-Waite-Smith deck. He set out to create his own set of cards for a few reasons: to update the Rider-Waite-Smith tarot cards, to tie tarot once again to ancient Egypt, and, perhaps most importantly to him, to outshine his famous rival Arthur Edward Waite. But he wouldn't take on this massive project alone. Much like Waite, Crowley would need the artistic skill of a talented woman to bring his ideas to life.

Lady Frieda Harris

1877–1962

Lady Frieda Harris

Lady Frieda Harris was an English artist born just one year before Pamela Colman Smith in 1877 in London. As Marguerite Frieda Bloxam, she had a middle-class English childhood, with a private education suitable for a young lady of the period, focused more on life skills than academics. This education included training in art, a subject in which she showed promise from a young age.

Not much else is known about her childhood, but at the age of twenty-four, she married Percy Harris, a British Liberal Party politician who was seen as something of a radical. Frieda Harris herself was a suffragette, and the two worked together to fight for the egalitarian political changes they believed in. The couple had two sons, Jack and Thomas, and earned the titles Sir and Lady Harris in 1932, when Percy was made a baronet. Although neither Lady Frieda nor Sir Percy had been born to noble families, this honor from the Crown offered them a respected position in society.

After spending many years supporting her husband's career and raising their two sons, Harris revisited her interest in the arts in her forties. Although art was a risky profession for women of her time, her elevated social status allowed her to pursue painting. She wrote and illustrated a book, *Winchelsea, A Lesson*, in 1926, which was inspired by the Greek god Dionysus— a reflection of her appreciation for fantasy and myth. During

this time, Harris also created artwork under the pseudonym Jesus Chutney, perhaps to avoid the judgment that might surface from using her title or to protect the reputation of her husband as a public figure.

In 1937, when she was sixty, she was introduced to Aleister Crowley, whom she urged to pursue his vision of creating a new tarot deck—with her help. Harris was familiar with the occult movement, had studied Madame Blavatsky's teachings, and had already become acquainted with several mystical artists and writers. After meeting Crowley, her interest in such topics grew, and she began to focus on his work, becoming his student in the art of divination. Harris was an amateur pupil of magic and depended on Crowley to enter this new realm of study. In turn, he depended on her for a monetary stipend, which allowed him to work on *Book of Thoth: A Short Essay on the Tarot of the Egyptians*, his writings on tarot. It's important to note Harris's enablement of Crowley's project, which stands in stark contrast to the dynamic of the working relationship between Smith and Waite. From the start, her financial status created an equal partnership and collaboration between herself and Crowley.

The pair set out together to create *The Thoth Tarot* deck and its accompanying text, *The Book of Thoth*, which would elaborate on the meaning behind the cards and how to use them. While Crowley was responsible for the writing, Harris took on the role of artist and illustrator to bring the project to life. The creation of the work was funded entirely by Harris, which gave her a great amount of artistic freedom and control of the

project. She enrolled in private synthetic projective geometry lessons, which taught her to use math to draw upon the Italian Renaissance approach to perspective to create a sense of symmetry and balance in the artwork for the deck. She used this method to try to convey the fourth dimension—or the essence of time. Her work included art deco motifs alongside these mathematical elements, making her style completely unique and magical.

Her work on this project was consuming, and she retreated to Chipping Campden, a small town in Gloucestershire, England, to paint in solitude with total focus on the project. Although she and her husband were by then living separately, their relationship remained mostly solid, with Sir Percy visiting her often and Lady Frieda making frequent trips back to London for events and holidays.

In 1944, a limited edition of 200 copies of the *Book of Thoth* was introduced through the publication associated with Crowley's magical organization. However, the deck itself was not printed until 1969, well after both Harris's and Crowley's deaths. The book outlined the philosophy of the cards and included illustrated plates to show the vision for the deck and was the amalgamation of all the philosophies Crowley was versed in, including Egyptian legend, astrology, Kabbalah, astronomy, and tarot, gathered together under the blanket of Thelema, the religious movement he founded. Harris worked to combine her mystical studies with her painting, creating an entirely new creative experience from the traditional art she'd been taught as a young woman.

While the partners initially expected to finish the project in six months, it took five years to complete, with Harris putting an incredible amount of thought and detail into her work, often editing and repainting her designs several times until she was satisfied. Work on the deck was also impacted by World War II, which caused intense upheaval, restrictions to daily life, and the severe rationing of food and supplies. Even in the midst of all this, Harris used her high-society connections to secure financial investors for the deck, as well as funding for the accompanying book and exhibition of paintings in 1941 and 1942. It's said that Crowley's name wasn't associated with the exhibitions, perhaps as a way to keep Percy Harris's notoriety clear of a magician with such a controversial reputation.

Harris's working relationship with the eccentric Crowley wasn't free of struggles. Indeed, there were months of disagreements and threats of legal action when Crowley felt he deserved credit for the artwork Harris was exhibiting. Contention over ownership and credit seems to be a thread throughout history between deck authors and their artist collaborators. Although Harris had painted the artwork herself, Crowley felt ownership of the magical studies that brought her to the point of creation. It seems that the working partners were able to resolve their differences by the time the *Book of Thoth* was published, however, and Harris continued paying a stipend to her magic instructor for many years.

In 1947, Aleister Crowley died at the age of seventy-two of a chronic bronchitis infection. According to their letters, he and Harris remained in contact throughout this time, with her

visiting him until his final days. Five years later, her husband Percy died at the age of seventy-six, leaving Harris without the two most influential men in her life. She was seventy-five years old at this point and decided to relocate to Ceylon after becoming friends with Ram Gopal, an Indian dancer who had toured with his company throughout England. The two shared an interest in occultism and spirituality, and because of this shared passion, Gopal invited Harris to design sets for his performances. Her prior studies of Buddhism and Hinduism inspired her to continue her spiritual quest in Asia, exploring meditation and consulting with a holy woman. She died in 1962 in Srinagar, India, at the age of eighty-five, but not before ensuring that her original paintings for the *Book of Thoth* would survive—by entrusting them to her colleague Gerald Yorke. He found them a home at the Warburg Institute in London, where they are housed today.

While Harris's place in society helped her voice to be heard and her connections allowed her to solicit financial backers for the exhibition of the paintings for the Thoth deck cards, it is her artistic genius that made the deck so special, and to this day it is one of the most popular decks in use around the world. The histories of both Lady Frieda Harris and Pamela Colman Smith feature male occultists who relied on the creative sensibilities of brilliant female artists to fuel their own legacies. In contrast to Smith's lack of credit for her work, however, Harris makes a glowing appearance in Crowley's introduction to the book, in which he says she "devoted her genius to the Work."

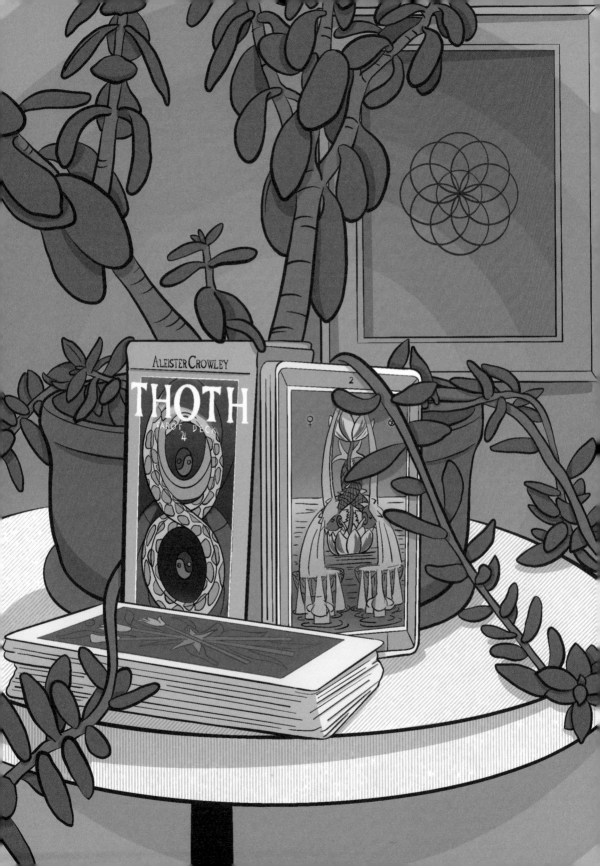

The Thoth deck is often referred to as the second most popular tarot deck in the world after the Rider-Waite-Smith deck. Besides the differences in style between the two, their major point of divergence is accessibility. While Arthur Waite and Pamela Colman Smith set out to create a deck that could be read and related to by anyone, Aleister Crowley and Lady Frieda Harris's work is shrouded in symbolism. A deeper study of occultism is required to really understand the Thoth iconography, making the accompanying guidebook essential to the experience of decoding the deck's layers of meaning. While both decks contain seventy-eight cards, they offer tarot enthusiasts two very different options to choose from.

Into the 1960s, Americans increasingly accepted tarot into mainstream culture, with decks appearing in conventional stores for anyone to buy. This was thanks in part to a man from the Bronx named Stuart Kaplan. In 1968, when he was thirty-six, Kaplan was on a business trip in Europe and stopped at the Nuremberg International Toy Fair in Germany to explore new games for his children. The toy fair has been a hub for toy and game entrepreneurs since 1949, inviting guests from all over the world each year. It was here that Kaplan spotted a deck of tarot cards called the Swiss IJJ, an iteration of the Marseille deck. He brought the cards back to New York and began distributing them to bookshops. Shortly after, he wrote an instructional manual for the cards and started the first company to carry tarot cards in the United States, U.S. Games Systems, Inc. Kaplan eventually gained the rights to the Rider-Waite-Smith deck and completed extensive research into Pamela Colman

Smith's life and work. He deserves a great deal of credit for not only bringing tarot to everyday consumers in the States, but also for surfacing Smith's accomplishments.

The 1960s and '70s represent yet another moment of societal transformation in which tarot and the occult experienced a resurgence in popularity. Against the backdrop of the Vietnam War, the civil rights movement, counterculture, women's liberation, and mass protests, it makes sense that many sought deep inner guidance. The development of the New Age movement spurred an uptick in tarot usage, especially because it could appeal to people of any or no spiritual background, offering intuitive guidance amid social changes. The New Age movement encouraged people to look to nature and within themselves for answers—both places where tarot cards could fit comfortably. And whether a person believed in the divine attributes of tarot or not, they could still use a deck as a tool to channel their own internal voice or insight. Astrology, magical practices, and tarot became associated with the New Age movement, as did some Eastern philosophical beliefs, such as reincarnation. Many hippies, in the United Kingdom especially, looked to India for spiritual guidance and began to study Buddhism, the Tao, Eastern meditation practices, and yoga. And as Europeans and Americans were seeking spiritual guidance in Southeast Asia, one woman was working to bring tarot from the Western world back to the East.

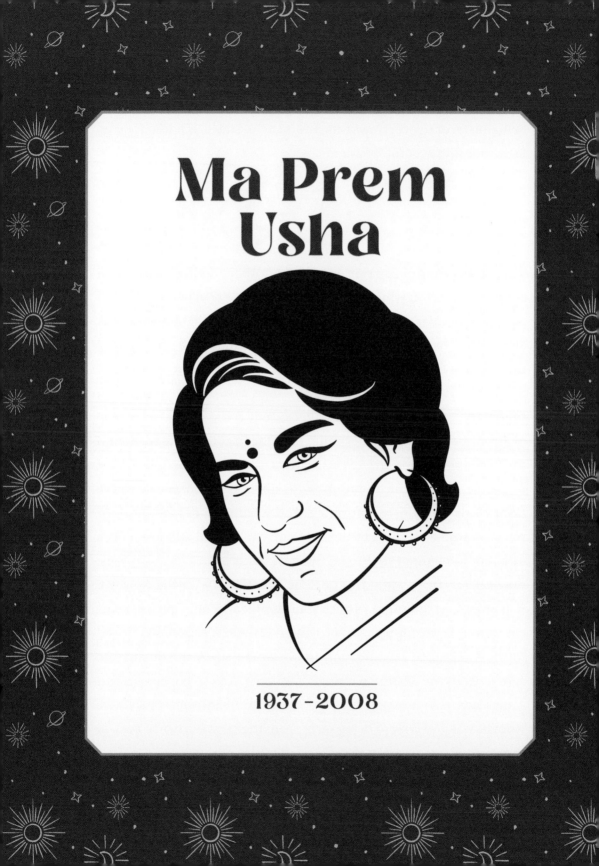

Ma Prem Usha

1937-2008

Ma Prem Usha was an astrologer, writer, fortune teller, spiritual teacher, and tarot reader who was born in 1937 in India. She attended university at the Isabella Thoburn College, a women's college in Lucknow, India, and went on to become a textile designer, creating costumes for films.

In her early thirties, Usha discovered the teachings of Osho, also known as Bhagwan Shree Rajneesh, a controversial Indian guru, and became a devoted follower of his. Although Rajneesh's teachings, and later his famously problematic commune, brought conflict into the hippie movement, his philosophies of nonattachment, meditation, and rejection of organized religion sparked something powerful within Usha. After meeting with and studying under Rajneesh, she delved into mystic practices, including energy healing and dynamic meditation, which ultimately led her to discover tarot cards.

Usha described tarot as a combination of astrology, symbology, and numerology, as well as the occult, and she embarked on a mission to popularize it for an Indian audience. She traveled throughout the world, offering tarot and clairvoyant readings for clients, all while praising tarot's intuitive power and universal appeal. Usha claimed to be the first card reader to write tarot predictions for publications, creating weekly readings for major Indian periodicals and conducting interviews. In the late 1990s, TV news channels asked her to use tarot cards to predict the outcome of the Y2K conundrum—she assured viewers that the initiation into the new millennium would be just fine. She also asserted that India would steadily become a software superpower into the 2000s, and both of her predictions ultimately came true.

Claiming that tarot was a complex, sensitive, and universal practice, Usha felt that tarot came to humans through divine means and that the true origin of the practice was unknown. She believed that the Romani people kept tarot alive throughout history, but that Westerners were skeptical of their practices and dismissed them, which is why the genesis remained a mystery for so long. But above all, Usha believed that optimism is extremely powerful and one can change their life with positive thinking.

Usha continued to practice tarot throughout her life, garnering millions of readers for her columns and publishing twelve books on astrology. She died in New Delhi at the age of seventy in 2008, having fulfilled her life's mission of spreading tarot throughout Southeast Asia and leaving a legacy as one of the most famous tarot readers in India.

Eden Gray

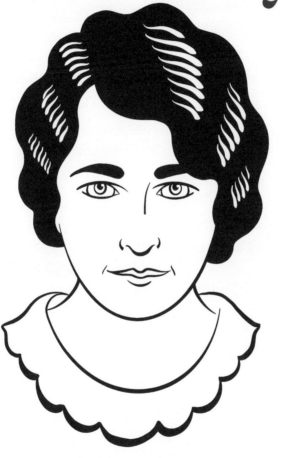

1901-1999

With the popularization of tarot in North America came the need for a modern instruction manual. While Waite's *Pictorial Key to the Tarot* was still in print and included with every Rider-Waite-Smith tarot deck, many readers desired a more beginner-friendly handbook. A former actress–turned–esoteric bookstore owner named Eden Gray set out to solve this problem.

In 1969, she published her first book, *Tarot Revealed: A Modern Guide to Reading the Tarot Cards*, followed by *A Complete Guide to the Tarot* in 1970 and *Mastering the Tarot: Basic Lessons in an Ancient, Mystic Art* in 1971. These books acted as a bridge between the Rider-Waite-Smith deck and the American public and broke down the barrier that esoteric knowledge had previously posed for those who wished to use the deck. And because Gray's books taught more people how to employ the RWS deck, her efforts significantly contributed to its popularity and ultimate destiny as the most beloved tarot deck in the world. Gray continued to teach and write about tarot, using her bookstore and publishing house to spread her knowledge of cards. Her books are still used by tarot readers today, offering novices basic guidance and seasoned readers an invaluable resource. It's worth noting that in 1975, tarot readers were facing arrests for fortune-telling—a practice that is still, believe it or not, illegal in many parts of the United States (though this is rarely enforced). Since tarot still maintained a deep link to fortune-telling at this time, practicing it was a somewhat radical endeavor.

Kaplan, who had been busy during these years working to bring tarot into the hands of customers, published an *Encyclopedia of Tarot* in 1978, which not only guides readers in using various decks, but also offers a comprehensive history of tarot. With this

publication, there were no longer any barriers between eager practitioners and their cards, setting the practice up to remain relevant for decades.

Mary K. Greer

b. 1947

Mary K. Greer, renowned tarot scholar and author, was born in 1947 in Denver, Colorado. She discovered Eden Gray's works when she was in college in 1967, and it sparked her lifelong interest in tarot. She published *Tarot for Your Self*, an award-winning book that challenged the previous taboo against tarot readers reading for themselves and included a workbook for the reader—the first of its kind. Greer went on to conduct extensive research into the Order of the Golden Dawn, Pamela Colman Smith, and Lady Frieda Harris, writing several more books and lecturing on tarot worldwide. Her work spans four decades and remains a reliable source of information for both seasoned readers and beginners.

It seemed that the popularity of tarot in the 1960s, '70s, and into the '80s was due in part to its resonance with people of varying backgrounds. As a practice not connected to one specific religion or belief system, it could prove useful and comforting to individuals from all walks of life. Long past were the days of tarot cards belonging only to men of a certain class. What was once a practice reserved for the most exclusive clubs could now be seen as a beacon of strength for those on the fringes of society. Rachel Pollack, an activist, tarot expert, and transgender icon, became a leader for underrepresented groups, using tarot as a vehicle for magic, possibility, and inclusivity.

Rachel Pollack

1945-2023

Rachel Pollack

Rachel Pollack was a cherished American tarot expert, science fiction author, feminist, and activist. She passed away on April 7, 2023, after living and working in upstate New York for many years.

Born in 1945 to a Jewish family in Brooklyn, New York, Pollack was considered one of the world's foremost authorities on the interpretation of tarot. She studied English before launching her writing career in 1971 with the publication of her first short fiction story "Pandora's Bust." That same pivotal year, she came out publicly as transgender and queer, and she discovered tarot. At the age of thirty-one, she received gender affirmation surgery while living in Holland, because at that time in the United States transgender people were treated as psychologically ill and were subjected to mistreatment and ignorance by the medical world and society at large. In spite of this, Pollack moved back to the States in the 1990s, living her truth while delving into an exploration of her spirituality. Pollack has said that she maintained a lifelong interest in all religions, rather than ascribing to one organization or church. She was captivated by the rebellious aspects of religion—the countercultures that most religions produced and the magical elements of belief systems.

In the early 1980s, Pollack's tarot studies led her to publish *Seventy-Eight Degrees of Wisdom* in two volumes. These remain two of the most influential books on card meanings, decoding tarot for thousands of readers. Rather than relying on historical symbolism or ancient lore to interpret the cards, *Seventy-Eight Degrees*, now printed as one volume, approaches tarot cards as images that can bring meaning to present-day readers. Its modern perspective and succinct history of tarot made it instrumental in the tarot revival of the 1980s in the United States and secured Pollack the moniker "Mother of Modern Tarot." Rather than positioning tarot as a fortune-telling device, Pollack saw it as a tool for guidance and internal exploration. And with this example, she inspired generations of tarot readers and divinators to make the cards more accessible to all.

Pollack went on to write twelve books on tarot, including *Salvador Dali's Tarot*, *Teach Yourself Fortune Telling*, *The New Tarot*, and *The Haindl Tarot*. Her work has been translated into sixteen languages and continues to be a learning tool for both novices and seasoned readers. In addition to writing about tarot, Pollack published several science fiction novels throughout her life, including her self-proclaimed favorite, *Unquenchable Fire*. Her books frequently showcase female heroines and depict women in relationships with other women.

Alongside her studies on tarot, Pollack worked as a writer of the popular DC comic series *Doom Patrol*, a channel through which she developed DC's first openly transgender

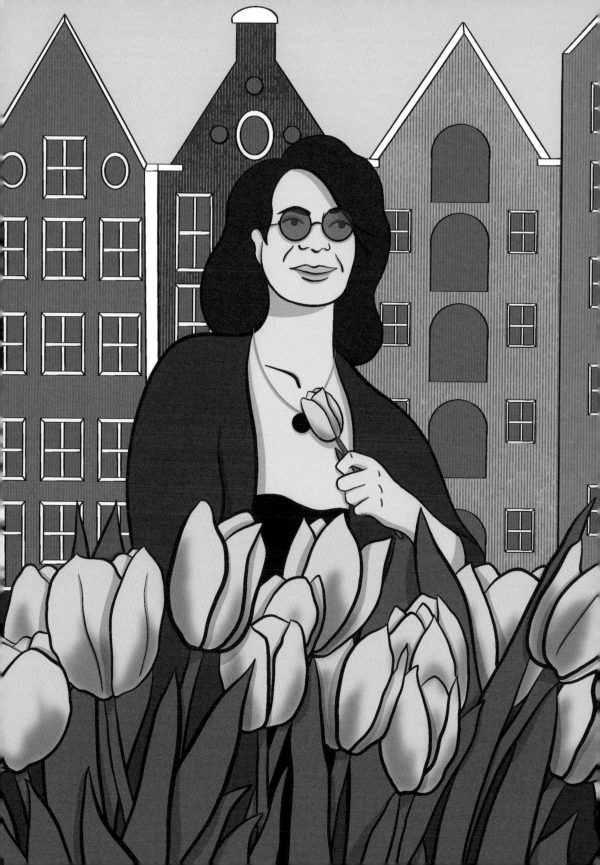

superhero: Coagula. Coagula made her debut in 1993 and continued to be an important character for the series. Through her writing, Pollack fought to bring LGBTQIA+ characters into the world of superheroes and used her own life experience as a model to create visibility for trans people. In a 2020 interview with writer and witch Pam Grossman, Pollack likened reading tarot cards to reading comics, explaining that both are composed of words and imagery and contain a story arc that engages the reader and usually results in a positive or uplifting ending.

In 1992, Pollack created her own deck—*The Shining Woman Tarot Deck*. After exploring tarot extensively for many years, as well as researching prehistoric art and goddess lore, Pollack looked to those themes to create a truly unique deck. After sketching out her ideas for the cards and searching for an artist to bring her vision to life, an unlikely turn of events led her to create the artwork herself. The incredible French American artist Niki de Saint Phalle invited Pollack to visit her in Italy and teach her about tarot in preparation for her own tarot-inspired projects. Saint Phalle went on to create a gorgeous tarot deck, which is now housed in the permanent collection of the Metropolitan Museum of Art. As soon as Pollack shared her sketches for *The Shining Woman Tarot Deck* with Saint Phalle, the artist asserted that Pollack must draw the cards herself. She did just that, and the deck continues to resonate with readers around the globe today. In an effort to invite readers of all genders and backgrounds into the world of tarot, she rereleased it in 2001 as *The*

Shining Tribe Tarot Deck. More culturally diverse than tradi-tional decks, *The Shining Tribe Tarot Deck* includes systems that tap into Neolithic rock art, Native American and Afri-can shamanism, Aboriginal art, the Kabbalah, Jungian psy-chology, and the traditional tarot.

The Shining Tribe Tarot Deck was not Pollack's only foray into deck creation. Expanding on her love for comics, she collaborated with *The Sandman* author Neil Gaiman to create the *Vertigo Tarot* in 1995. Inspired by the beloved adult DC imprint Vertigo Comics, which included *The Sandman*, the *Vertigo Tarot* was a limited-edition collection of seventy-eight cards illustrated by artist Dave McKean and a guidebook written by Pollack, with a foreword by Gaiman. This deck further cemented Pollack's mission to spread tarot to those who might not be familiar with it—always meeting them in the space where they felt most comfortable. With the *Vertigo Tarot* deck, comic readers and superhero fans could learn to appreciate tarot in a way that was meaningful to them. The deck has been republished since, holding a special place in the hearts of DC aficionados.

Pollack's prolific output in the realm of tarot didn't end there. She wrote *Tarot of Perfection* in 2008, a book of fairy tales based on tarot, which opened new ways of seeing and meditating on the cards. Four years later, she published *The New Tarot Handbook*, which compiled her forty years of tarot expertise into one master guidebook. In true Pollack fashion, the book offers meaningful instruction for tarot readers at any level.

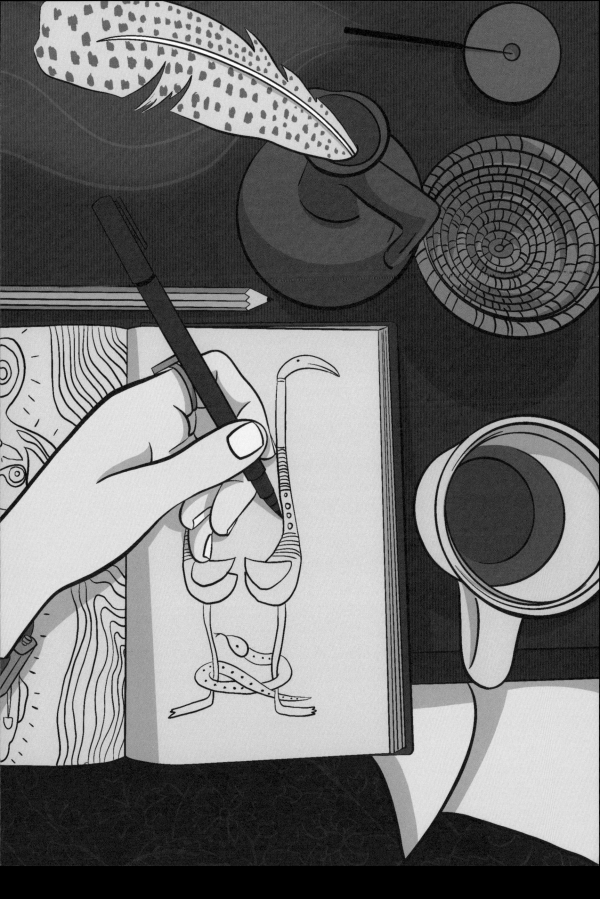

In 2014, Pollack set out to create yet another tarot deck. *The Burning Serpent Oracle: A Lenormand of the Soul* was inspired by the Lenormand deck and takes that traditional deck to the next level. While the Lenormand deck is a collection of everyday symbols, such as the heart or the key, *The Burning Serpent Oracle* infuses these symbols with spiritual meaning. The deck can be read as a standard Lenormand deck or as one with more complex storytelling. Illustrated by Robert M. Place, creator of the *Alchemical Tarot* deck and tarot historian, the deck showcases gorgeous, vibrant, and narrative artwork and comes with an accompanying book written by Pollack. The book offers a history of Lenormand card reading, as well as explanations for each card's symbolism and instructions for reading, while in the deck itself Pollack seemingly collaborates with Marie Anne Lenormand across time to create something traditional yet new, even though more than a century stretched between the two women's lives. A few years after the printing of their first deck, Place and Pollack collaborated on *The Raziel Tarot*, which called upon ancient Judaic mythology and combines the artistic style of the Rider-Waite-Smith deck with Jewish Art Nouveau. Named for the angel Raziel from Judaic myth, the deck is deeply spiritual and imaginative, as it explores the mystery of creation. While this unique deck stands alone among Pollack's other works, it is also clearly part of her lifelong sacred explorations.

Pollack taught about tarot for decades, offering lectures and new concepts to the occult community through her

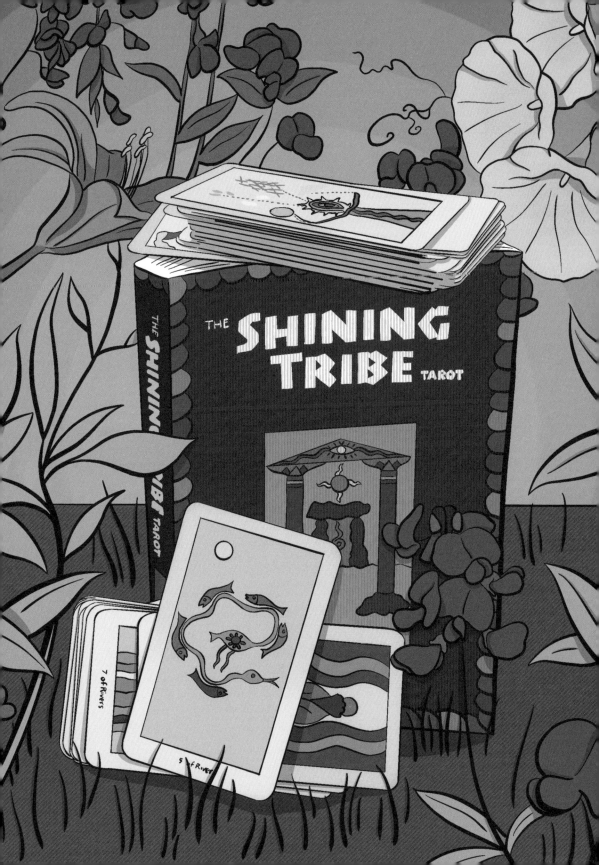

ongoing seminars at the Omega Institute alongside tarot expert Mary K. Greer, all while maintaining her award-winning writing career. She worked as a professor at Goddard College's MFA writing program until her retirement, sharing her wisdom with the next generation of writers. In addition to her work as a writer and tarot reader Pollack expressed that magic practices were a part of her life, and in her interview with Grossman, she said that "when you start to pay attention, you discover how magical the world is." Certainly, through her incredibly vast and varied body of work, Pollack has left the world a more magical place than the one she entered.

Partially thanks to the efforts of Rachel Pollack and others working toward accessibility, tarot remained popular into the 1990s, as practitioners embraced the different decks and methods of reading available to them. While the rich history of tarot could never be completely stripped from the cards, by the end of the twentieth century, the ability to use tarot as a tool for self-reflection had perhaps become more important than its ancient origins.

As younger generations in the United States move away from organized religion in the twenty-first century, forming the largest group of secular people in the history of the country, practices like tarot and astrology are gaining popularity. Since the early 2000s, tarot has become an increasingly prominent part of mainstream American culture, with the Rider-Waite-Smith deck remaining the standard for cards. According to Ruth West, the creator of *Thea's Tarot*, a nontraditional, feminist, and lesbian-focused deck published in 1984, the practice of tarot is again being reclaimed by women in the twenty-first century, as it was in the nineteenth century. To combat the tradition of sexist ideology and cultural appropriation prevalent in tarot and secret societies of the past, modern-day artists and readers are responding by developing new and innovative decks that are accessible to anyone who wishes to channel the practice.

Into the 2020s, tarot continues to evolve with the times, taking on various forms to suit the people who use it. And just as they have throughout history, women continue to manipulate it with strategic intention, maintaining tarot's status as a powerful and insightful tool for intuitive magic.

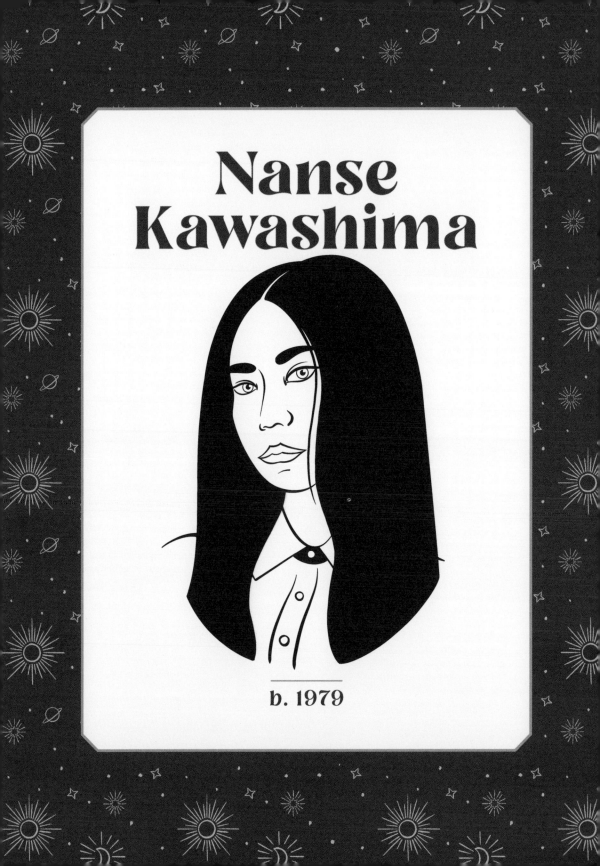

Nanse
Kawashima

b. 1979

Nanse Kawashima is an artist as well as a tarot reader, Reiki practitioner, and astrologer based in Brooklyn, New York. Born in Japan in 1979, Nanse had a childhood full of international moves, including relocating to El Salvador for her father's job in the coffee industry. As the country became more dangerous after the start of the Salvadoran Civil War, her parents fled Central America for Jamaica, followed by Hawaii, before moving back to Japan. Nanse studied design at a university in Tokyo before ultimately settling in New York City as an adult. Adapting to such a wide variety of cultures all over the world has influenced Kawashima's esoteric practices in many ways, exposing her to an array of spiritual systems.

Her work brings her back to her roots though, as she channels her maternal lineage from the north of Japan, which was full of clairvoyants and divinators. Both her grandmother and great-grandmother were deeply intuitive healers. Nanse acquired a Rider-Waite-Smith deck in Hawaii at the age of ten but felt bewildered by the symbolism and struggled to utilize it. Nevertheless, she remained a mystical child, soaking up the local lore of each place she lived and often making predictions and discoveries that adults equated with mischief. Today, Kawashima practices with the New Tarot Deck, an out-of-print collection of cards from 1974 that is wholly unique. After studying design in Tokyo and pursuing a career in fashion, Kawashima felt burned out and uninspired and decided to leave her job to focus on making art. Her creative practice ignited a passion for treasure-hunting in New York City's flea markets for interesting and unique items. It was this pastime that led her to stumble upon the New Tarot Deck by Jack Hurley and John Horler under a junk pile in a Chelsea flea market. According

to Kawashima, the deck at the bottom of the heap of miscellaneous items called to her, and she kept digging until she rescued it from an old paper bag. The cards were black and white, archetypal, and enchanting. The creators of the cards had been active in the tarot scene in the San Francisco Bay Area in the 1960s. Today this rare deck sells for hundreds of dollars on collector sites, but Kawashima managed to obtain it for just thirty-five dollars.

This pivotal discovery inspired Kawashima to learn to read tarot cards, and she began to conduct readings for her friends. With a natural talent for cards, combined with the special reading technique of the New Tarot Deck and her ancestral intuitive gifts, it quickly became clear that a reading with Kawashima was a truly special experience. She began to charge small sums of money for her readings in 2011 and established her company, Sibylline Vein. Her practice grew organically, eventually gaining attention from companies such as Swarovski, which hired her to share her work with attendees at events. Through her tarot practice, Kawashima shares the spiritual gifts she inherited from her maternal ancestors with her community. She became certified in Advanced Reiki, or Japanese energy healing, which she often combines with her tarot readings.

In 2016, Kawashima began studying Western astrology, in part to better understand some of the tarot symbolism she encountered, and began infusing her tarot readings with it. In addition to tarot and occult work, Kawashima is also a visual artist, using painting and collage to explore her inner landscape and repurpose ephemera to reveal different parts of her subconscious. Her work is deeply magical and captivating, coexisting peacefully alongside her tarot practice.

Kawashima believes that there is a current shift in society, with people moving away from so-called authorities on health and wellness as they take their spiritual healing into their own hands and pursue more holistic practices like therapy and tarot. With "more trust and honoring of female shamanism now than even centuries ago," she believes that people are more willing to seek out the work of tarot readers, and that women and their varied contributions to the evolution of tarot helped us get here.

As we see modern people attempt to channel their spirituality in a myriad of ways, tarot's acceptance into Western culture grows as a secular alternative to organized religion. The 2020s ushered in the heaviest resurgence of tarot since the 1970s, with online shopping, apps, social media, and occult products all making access to the teachings of tarot more convenient than ever. Stress and anxiety from global conflict, contentious elections, and the COVID-19 pandemic, as well as economic uncertainty, inequality, and systemic racism, have led to a collective yearning for answers, and thus an explosion in the global tarot market.

In 1999, Brigit Esselmont, a young university student, started her own website to post the meanings of the tarot cards from the Rider-Waite-Smith deck. She had been studying the deck but had trouble memorizing the meaning of every single card, and she had a hunch that others would face the same struggle. Her website became what is now known as Biddy Tarot, the leading online resource for tarot. With fifteen million visitors per year, Esselmont's website has helped people all around the world decode the meanings of their cards. Esselmont published *Everyday Tarot* in 2018, a book that combines tarot education with self-help guidance, opening up the practice to even more readers and normalizing it as a practical means to manifest one's ideal reality, whether through career growth or spiritual healing.

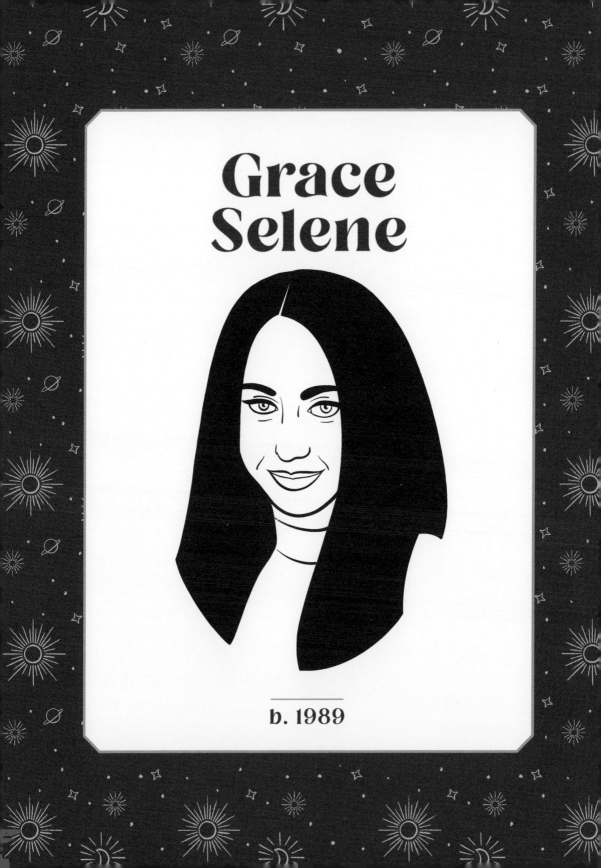

Grace
Selene

b. 1989

Grace Selene was born on October 21, 1989, in Cleveland, Ohio. At the young age of twelve, she discovered tarot at her local library where she was reading books on witchcraft. She'd just seen the popular 1990s movie *The Craft*, in which high school girls dabble in the world of supernatural phenomena, and was eager to begin her research into cards, spells, and sorcery. Like many girls who watched the movie at a young age, Grace became fascinated with the concept of working with energy, and she began to explore occult practices to cope with the trauma she'd endured during her childhood. Throughout high school, Grace excelled academically and aced her science classes. She went on to graduate from college with a degree in human biology, then advanced into medical research. Yet while she excelled at her studies, she remained spiritually unfulfilled. It was in her research lab, perhaps an unlikely setting, where Grace received her first tarot reading. A colleague had brought a tarot deck to work and offered to do readings during their break. That reading turned Grace's attention inward, and this emotional shift, prompted by the Rider-Waite-Smith deck's Moon card, led her down a lifelong endeavor to understand, utilize, and share the gifts of tarot. She bought a tarot deck that night and began a daily practice of pulling a card and journaling, a simple routine that changed the course of her career completely.

As a professional tarot reader with fifteen years of experience reading for over ten thousand clients and nearly 1.3 million community members, Grace offers meaningful spiritual practice and tarot readings through her business The Moon Tarot. Her goal is to provide her clients with the same mental and emotional support that tarot offered her to confront her tumultuous childhood.

By creating a safe space for self-discovery, Grace assists others in learning more about themselves and strengthening their own intuition. While conducting readings, Grace also teaches her clients how to read the cards themselves, hoping that tarot decks can become tools for reflection and wisdom in their own lives, thereby also demystifying the cards themselves. Through her own studies, she is aware of the roadblocks a tarot student can face, and she aims to make the story of tarot fit into a modern lifestyle.

When Grace was first starting out as a tarot practitioner, it was difficult for her to find information on the cards and their meanings. The internet, however, has made it possible for anyone interested to study the cards and their meanings freely, easily, and abundantly. Rather than this information being restricted to certain groups as it once was, anyone with access to an internet browser can delve into the learning material today. Additionally, it's much easier to purchase a tarot deck today than it once was. These shifts in accessibility align with Grace's long-term vision for the industry, which is making tarot more relatable and usable to everyone. As humans, she says, there are fundamental truths and tribulations that we all experience, and the cards portray them in a unique yet universal fashion. By making tarot's symbology digestible to anyone who wants to learn, Grace is helping our broader community connect, grow, and endure.

In today's world, as tarot maintains its foothold in mainstream culture, authors and illustrators are beginning to get creative with the delivery of the cards. Now that the practice is accessible to anyone who wishes to get started, the real opportunity lies in the way people are visualizing what a tarot card can be. From animals to queer iconography, tarot symbolism is evolving and taking on new forms, and while this list is by no means exhaustive, the following femme or nonbinary creators are working to reinvent what tarot means to them.

- Ash + Chess, creators of *Queer Tarot: An Inclusive Deck and Guidebook*

- Nyasha Williams, author of *Black Tarot: An Ancestral Awakening Deck and Guidebook*

- Moon Dust Press, creators of *My First Tarot Deck*, a twenty-two-card Major Arcana tarot deck for kids

- Adriana Ayales, herbalist and author of *The Herbal Astrology Oracle*, a Costa Rican remedy deck

- Lisa Sterle, illustrator and author of *Modern Witch Tarot Deck*

- Stasia Burrington, author and illustrator of *Sasuraibito Tarot Deck*

ACKNOWLEDGMENTS

I'd like to thank my family and friends for their endless support during the creation of this book. I wrote and illustrated *Women of Tarot* during my pregnancy and postpartum period, and I must extend my total appreciation to my partner Jonathan, who took on far more than his fair share of childcare to help me make this book a reality. To my son Tycho, who I was pregnant with and gave birth to during this project, thank you for giving me endless inspiration to try to make your future world a more enchanting place. You are pure love incarnated. To my stepson Emil, who never fails to offer helpful feedback, love, and optimism—thank you. To my parents Patrick and Terese, and my siblings Allyson, Lauren, and Patrick, who have been putting up with my wild ideas for a lifetime—thank you. Shannon Connors Fabricant and the team at Running Press, you are the most stellar collaborators I have encountered, and I'm so grateful for your edits, resources, and encouragement. And to Joan Brookbank, my agent and dear friend—it is an honor to be on the same team with you, and your steady hand keeps my work afloat.

BIBLIOGRAPHY

Butler, Kirstin. "What Happened When Zora Neale Hurston Studied Voodoo in Haiti?" *PBS*, January 6, 2023. Accessed online March 2023. https://www.pbs.org/wgbh/americanexperience/features/claiming-space-when-happened-when-zora-neale-hurston-studied-voodoo-haiti/.

Caduceus Books. "Lady Frieda Harris, Masonic Tracing Boards." July 8, 2017. Accessed online December 15, 2022. http://www.caduceusbooks.com/nextlist-7-17/index.htm.

Editors of Encyclopaedia Britannica. "Helena Blavatsky, Russian Spiritualist." *Encyclopaedia Britannica*, June 16, 2023. Accessed online June 2023. https://www.britannica.com/biography/Helena-Blavatsky.

Ellis, R. J., and Henry Louis Gates Jr. "'Grievances at the Treatment She Received 'Harriet Wilson's Spiritual Career in Boston, 1868–1900." *American Literary History*, vol. 24, no. 2, 2012. Accessed online February 2023. https://www.jstor.org/stable/23249769.

Greer, Mary K. "Mlle. Lenormand, the Most Famous Card Reader of All Time." *Mary K. Greer's Tarot Blog*, February 12, 2008. Accessed online March 2023. https://marykgreer.com/2008/02/12/madame-le-normand-the-most-famous-card-reader-of-all-time/.

Grossman, Pam. "Rachel Pollack, Tarot Titan and Radical Writer." *The Witch Wave*, June 24, 2020. Accessed online April 2023. https://witchwavepodcast.com/episodes/2020/6/23/55-rachel-pollack-tarot-titan-and-radical-writer.

Gustines, George Gene. "Rachel Pollack, Transgender Activist and
Authority on Tarot, Dies at 77." *New York Times*, April 13,
2023. Accessed online April 2023. https://www.nytimes
.com/2023/04/13/arts/rachel-pollack-dead.html.

Gyimah-Brempong, Adwoa. "Writer Rachel Pollack, Who Reimag-
ined the Practice of Tarot, Dies at 77." *NPR*, April 19, 2023.
Accessed online March 2023. https://www.npr
.org/2023/04/14/1168403462/rachel-pollack-obituary-tarot.

Herring, Emily. "Moina Mathers—High Priestess of the Belle
Époque." *Engelsberg Ideas*, May 28, 2021. Accessed online
February 2023. https://engelsbergideas.com/portraits
/moina-mathers-high-priestess-of-the-belle-epoque/.

Hess, Liam. "How Queen Nefertiti Used Her Beauty to Convey
Power." *Dazed Digital*, September 29, 2018. Accessed online
May 2023. https://www.dazeddigital.com/beauty
/article/41528/1/queen-nefertiti-beauty-power-egypt.

History.com Editors. "Nefertiti." History.com, June 15, 2010.
Accessed online May 1, 2023. https://www.history.com
/topics/ancient-egypt/nefertiti.

HT Correspondent. "Tarot Card Reader Ma Prem Usha Dead."
Hindustan Times, July 17, 2008. Accessed online March 2023.
https://www.hindustantimes.com/delhi/tarot-card-reader
-ma-prem-usha-dead/story-mGF9GdCiRBDZAatrj59QSJ
.html.

Hurston, Zora. "Hoodoo in America." *Journal of American Folklore*,
vol. 44, no. 174, 1931. Accessed online March 2023. https://
www.jstor.org/stable/535394.

Kaplan, Stuart R. *The Encyclopedia of Tarot*. Stamford, CT: United States Games Systems, 1978.

Kaplan, Stuart R., Mary K. Greer, Elizabeth Foley O'Connor, and Melinda Boyd Parsons. *Pamela Colman Smith: The Untold Story*. Stamford, CT: United States Games Systems, 2018.

Maille, Patrick. *The Cards: The Evolution and Power of Tarot*. Jackson: University Press of Mississippi, 2021.

Olsen, Christina. *The Art of Tarot*. New York: Abbeville Press, 2018.

Putnam, Frank Bishop. "Teresa Urrea, 'The Saint of Cabora.'" *Southern California Quarterly*, vol. 45, no. 3, 1963. Accessed online February 2023. https://www.jstor.org /stable/41169794.

Stevens, Anna. "Akhenaten, Nefertiti & Aten: From Many Gods to One." *American Research Center in Egypt*, February 9, 2019. Accessed online April 2023. https://arce.org/resource /akhenaten-nefertiti-aten-many-gods-one/#:~:text= The%20Aten%20cult%20afforded%20a,the%20androgy- nous%20creator%20god%20Atum.

Taronas, Laura. "Nefertiti: Egyptian Wife, Mother, Queen and Icon." *American Research Center in Egypt*, December 1, 2019. Accessed online May 2023. https://arce.org/resource /nefertiti-egyptian-wife-mother-queen-and-icon/.

U.S. Games Systems, Inc. "Stuart R. Kaplan Biography." February 9, 2021. Accessed online January 2023. https://www.usgames- inc.com/Biography.html.

Whitehouse, Deja. "'Mercury Is in a Very Ape-Like Mood': Frieda Harris's Perception of Thelema." *Aries*, December 14, 2020.

Accessed online December 2022. https://brill.com/view
/journals/arie/21/1/article-p125_6.xml?language=en.

Wills, Matthew. "Spiritualism, Science, and the Mysterious
Madame Blavatsky." *JSTOR Daily*, October 25, 2016.
Accessed online February 2023. https://daily.jstor.org
/spiritualism-science-and-the-mysterious-madame
-blavatsky/.

Women History Blog. "Voodoo Queen of New Orleans." *History of
American Women*, July 1, 2012. Accessed online March 2023.
https://www.womenhistoryblog.com/2012/07
/marie-laveau.html.

Zuckerman, Phil. "Religion Declining, Secularism Surging."
Huffington Post, May 13, 2017. Accessed online July 2018.
https://www.huffpost.com/entry/religion-declining
-secula_b_9889398.

INDEX

a

abolition, 68

Akhenaten, Pharaoh, 9, 11

Akhetaten (Tell el-Amarna), 9

Alchemical Tarot deck, 114

Alliette, Jean-Baptiste (Etteilla), ix, 13, 30

Alpha et Omega, 45

Art Nouveau, Jewish, 114

Ash + Chess, 128

astrology, 74, 122

Aten/Atenism, 9–11

Ayales, Adriana, 128

b

Barnard College, 78

Barrie, J. M., 63

Bembo, Bonifacio, viii, 3

Berlin Photographic Company, 63

Biddy Tarot, xi, 124

Black Tarot (Williams), 128

Blavatsky, Helena Petrovna, 35, 36–38, 87

Bloxam, Marguerite Frieda. *see* Harris, Frieda

Bonaparte, Joséphine, 24, 26

Book of Thoth (Crowley), x, 87, 89, 91, 92

Book of Thoth (Egyptian text), 6

Book T, 40

British Museum, 60

Buddhism, 92, 95

Builders of the Adytum (B.O.T.A.), 74–75

Burning Serpent Oracle, The (Pollack), 114

Burrington, Stasia, 128

c

Case, Paul Foster, x, 74–75

Catholicism, 68

Christianity, 75

Chutney, Jesus (Frieda Harris), 87

Coagula, 111

Cole, Alphaeus, 58

Complete Guide to the Tarot, A (Gray), 100

Court de Gébelin, Antoine, viii, 5–7, 12, 35

COVID-19 pandemic, xi, 124

Craft, The, 126

Crowley, Aleister, x, xi, 45, 80, 87, 89, 91, 92, 94

d

d'Ancona, Nicola di Maestro Antonio, viii, 4

DC Comics, 109, 111, 112

Debussy, Claude, 63

Doom Patrol, 109, 111

e

Encausse, Gérard (Papus), ix, 39

Encyclopedia of Tarot (Kaplan), xi, 100–101

Enlightenment, 12

Esselmont, Brigit, xi, 124

Etteilla (Jean-Baptiste Alliette), ix, 13, 30

Everyday Tarot (Esselmont), 124

f

French Revolution, 22

g

Gaiman, Neil, 112

Gall, Franz Joseph, 21

Goddard College, 116

Golden Dawn Tarot deck, 44. *see also* Hermetic Order of the Golden Dawn

Gopal, Ram, 92

Grand Etteilla Tarot, ix, 13, 30

Gray, Eden, x, 99–101, 103

Greer, Mary K., xi, 44, 102–103, 116

Grimaud, 30

gris-gris, 72

Grossman, Pam, 111, 116

Guggenheim Fellowship, 78

h

Haindl Tarot, The (Pollack), 109

Harris, Frieda, x, xi, 83–93, 94, 103

Harris, Percy, 85, 89, 91–92

Herbal Astrology Oracle, The (Ayales), 128

Hermetic Order of the Golden Dawn, ix, 40, 43–45, 51, 58, 59, 74, 103

Hermeticism, 60

Hinduism, 92

Hoodoo, 75, 78

Horler, John, 121

Horniman, Annie, 44

Hurley, Jack, 121

Hurston, Zora Neale, 76–79

i

Introduction to the Study of Tarot, The (Case), x, 74

invention of tarot, 2

Isabella of Lorraine, Duchess, 2–3

Isabella Thoburn College, 97

Isis Temple, 45

Islam, 2

j

Jewish Art Nouveau, 114

Journal of American Folklore, 78

k

Kaplan, Stuart, x, xi, 94–95, 100

Kawashima, Nanse, 120–123

l

Lake, Nora, 65

Laveau, Marie Catherine, 69, 70–73, 78

Le Monde Primitif (The Primeval World; Court de Gébelin), 12